Fashion is...

Fashion is...

THE METROPOLITAN
MUSEUM OF ART

Abrams
New York

FROM LEATHER TO LACE, from sandals to stilettos, from art to music, fashion is . . . just about anything.

The following pages, with nearly two hundred definitions of fashion, pair simple descriptions with a range of costumes, artifacts, and works of art from the Metropolitan Museum's encyclopedic collection, including The Costume Institute. The Costume Institute alone houses more than 35,000 costumes and accessories spanning five continents and seven centuries. The single largest and most comprehensive costume collection in the world, it offers an unrivaled timeline of fashion history.

The descriptions given are subjective observations that are open to discussion. Fashion is a ruffle, fashion is a crease. Fashion is for the head, fashion is for the feet. Fashion is denim, fashion is diamonds. Some of the responses speak to technique, while others are descriptive or evocative. Detailed commentary about the featured works of art can be found on the Museum's website at www.metmuseum.org.

Because fashion has no limits, readers are encouraged to react, to think, and to create their own definitions of "fashion."

Fashion is leather,

Evening Dress
Donatella Versace, Italian, b. 1955
For Gianni Versace, Italian, founded 1978
Leather, spring / summer 1999
Gift of Donatella Versace, 1999 1999.137.2

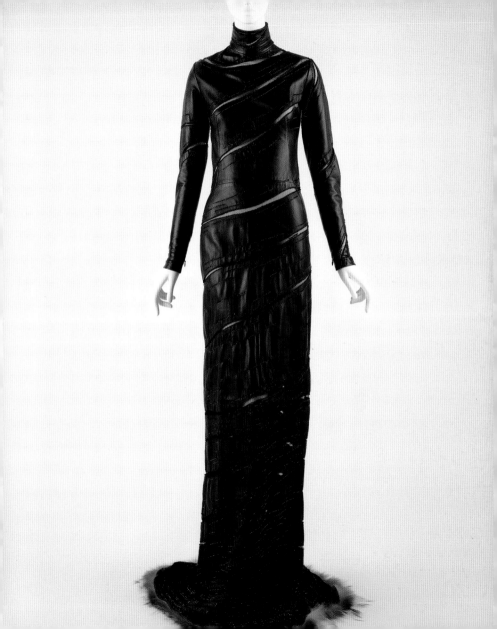

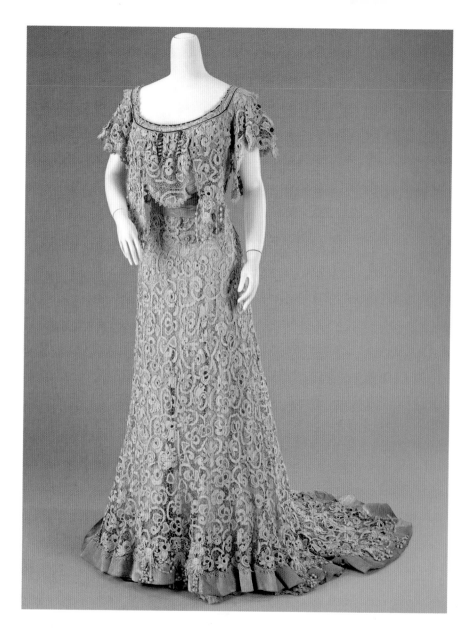

fashion is lace.

Evening Dress
Charles Klein, French
Cotton, silk; ca. 1910
Brooklyn Museum Costume Collection at The Metropolitan
Museum of Art, Gift of the Brooklyn Museum, 2009;
Gift of Mr. and Mrs. Maxime L. Hermanos, 1961 2009.300.1283

Fashion is opulent,

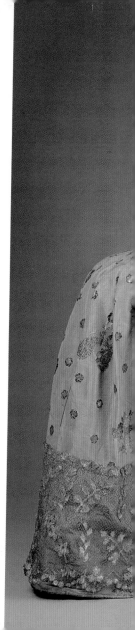

Court Dress
British, ca. 1750
Silk, metallic thread
Purchase, Irene Lewisohn Bequest, 1965
C.I.65.13.1a–c

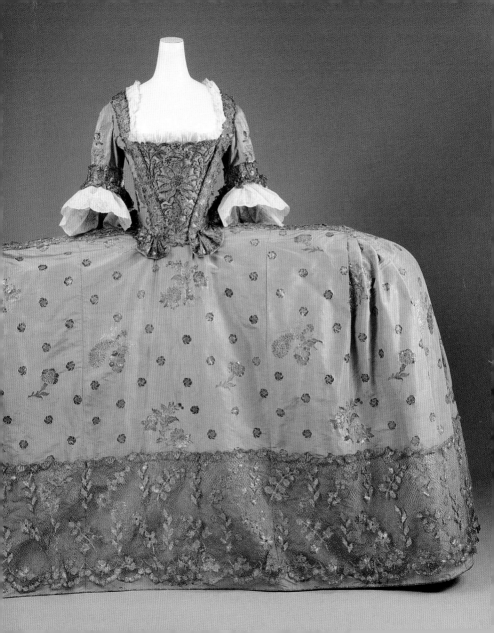

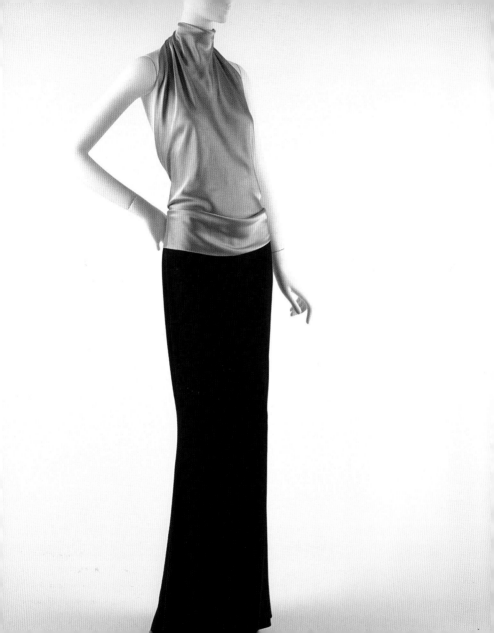

fashion is unadorned.

Evening Ensemble
Calvin Klein, American, b. 1942
Silk, acetate, rayon; fall / winter 1987–88
Gift of Calvin Klein, Inc., 1998 1998.508.40a, b

Fashion is ribbons,

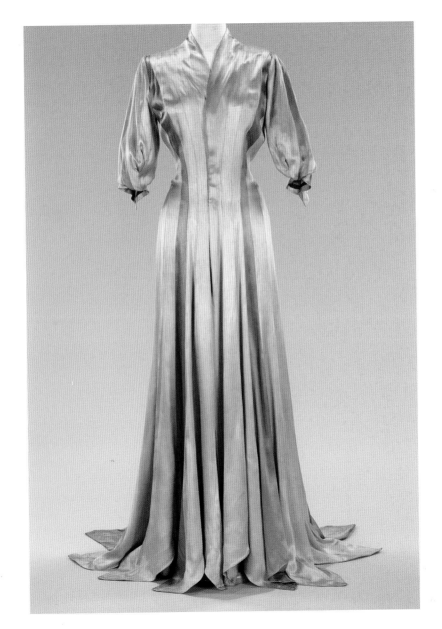

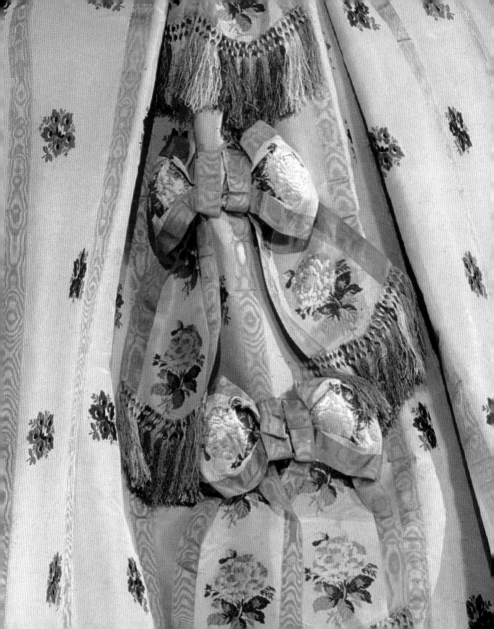

fashion is bows.

Ball Gown

American, 1861–62

Silk

Gift of Russell Hunter, 1959 C.I.59.35.4a, b

Fashion is a ruffle,

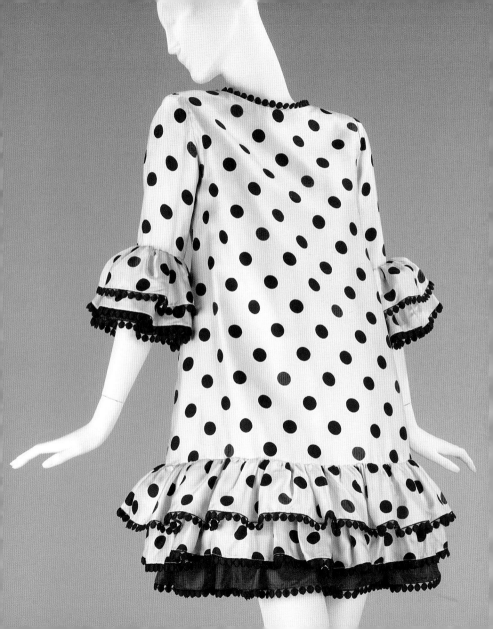

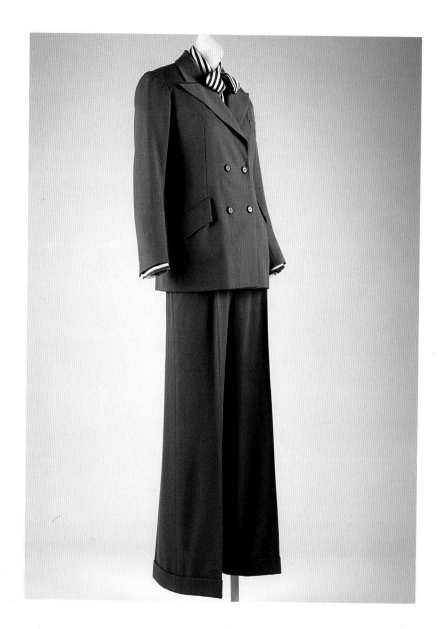

fashion is a crease.

Pantsuit

Yves Saint Laurent, French, 1936–2008

Wool, spring / summer 1970

Gift of Mireille Levy, 1984 1984.163.4a, b

Fashion is provocative,

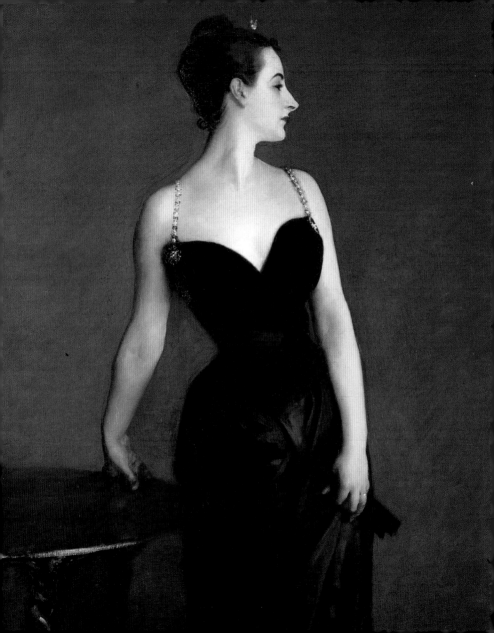

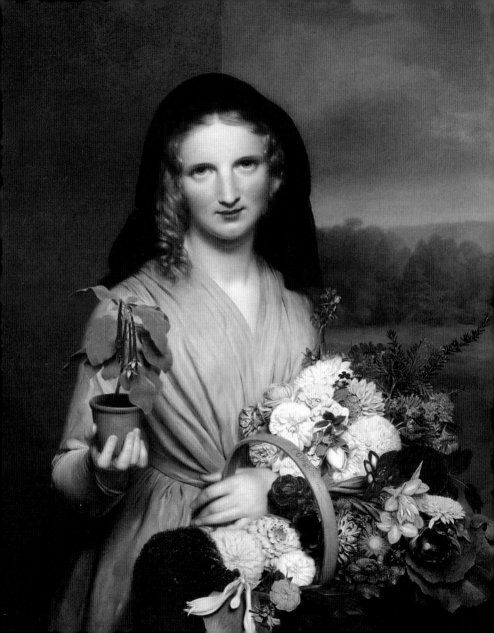

fashion is demure.

Fashion is texture,

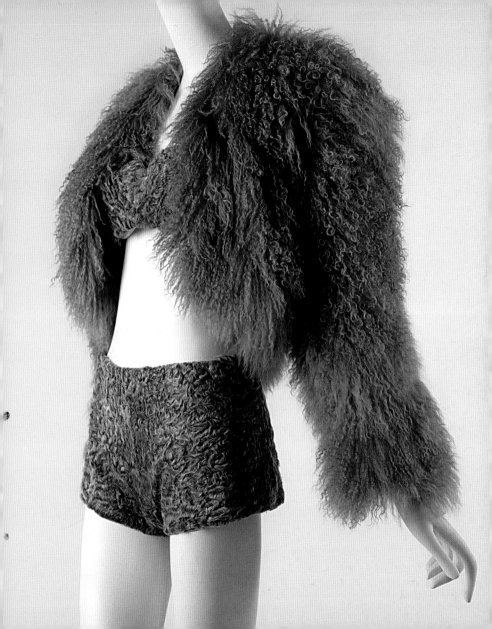

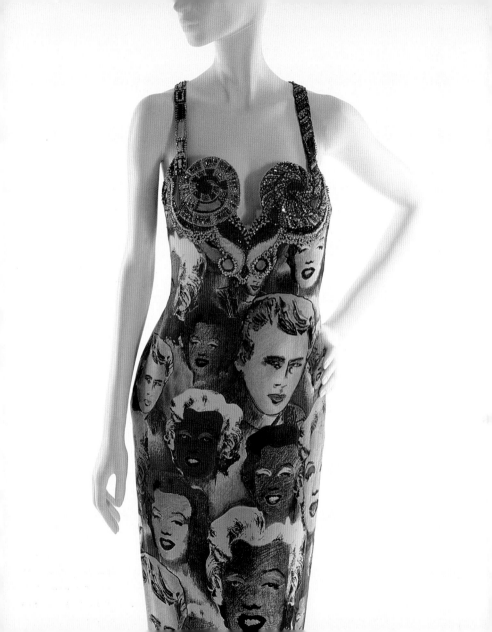

fashion is pattern.

Evening Dress

Gianni Versace, Italian, 1946–1997

Silk, glass; spring / summer 1991

Gift of Gianni Versace, 1993 1993.52.4

Fashion is silk,

Dress

Tom Ford, American, b. 1961

For Gucci, Italian, founded 1921

Silk, spring / summer 2003

Gift of Gucci, 2003 2003.442

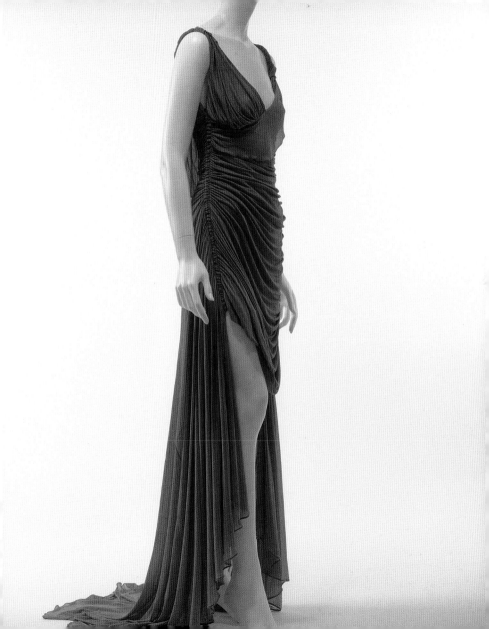

fashion is tweed.

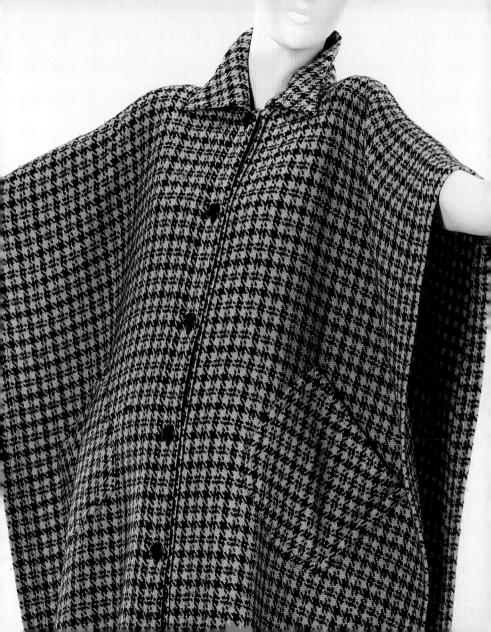

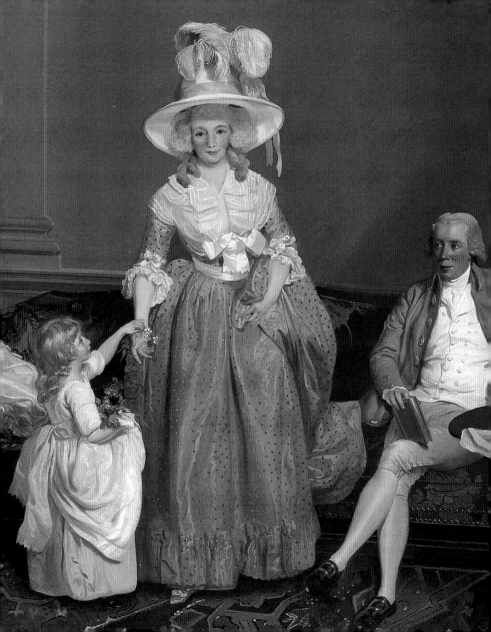

Fashion is a hat,

fashion is a crown.

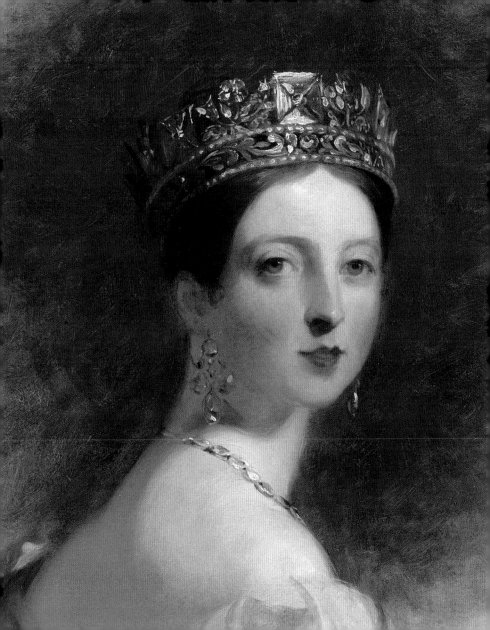

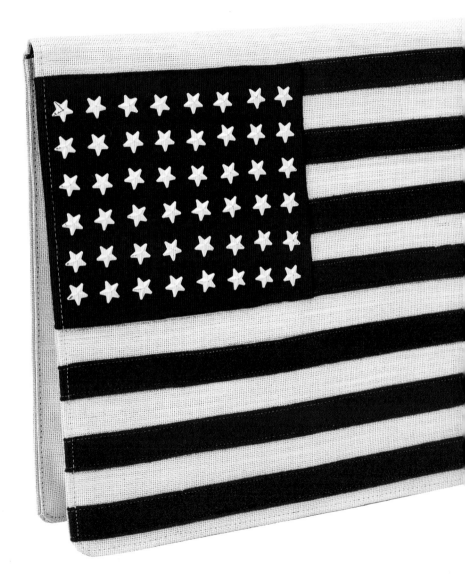

Fashion is patriotic,

fashion is devotion.

Chadri
Afghan, 20th century
Cotton, silk
Gift of Diana Vreeland, 1972 1972.253

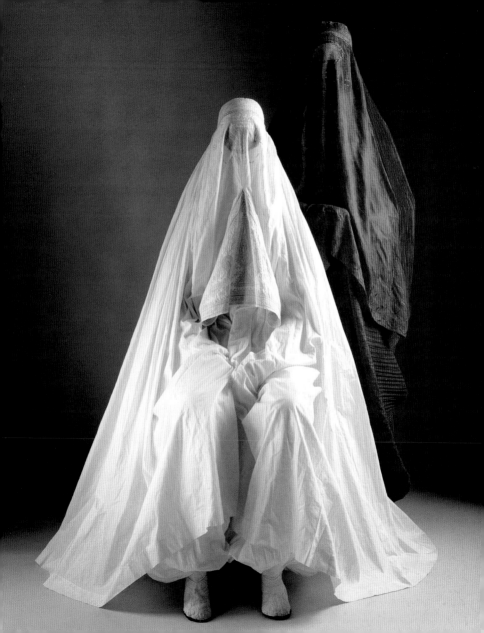

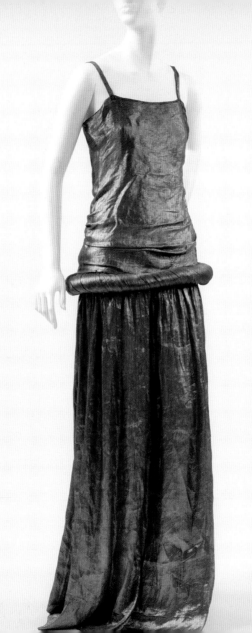

Fashion is fluid,

fashion is structure.

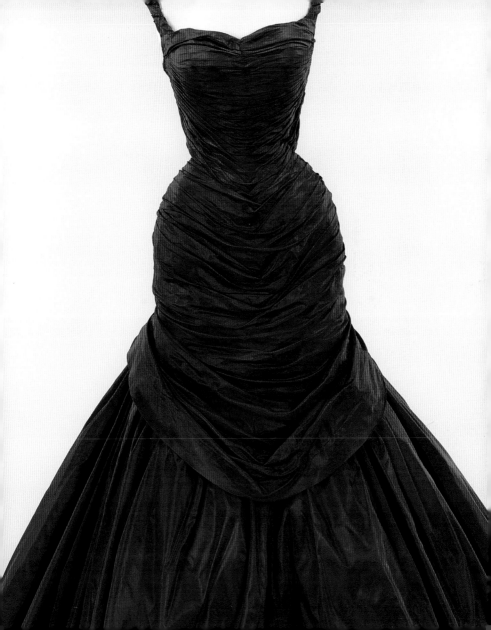

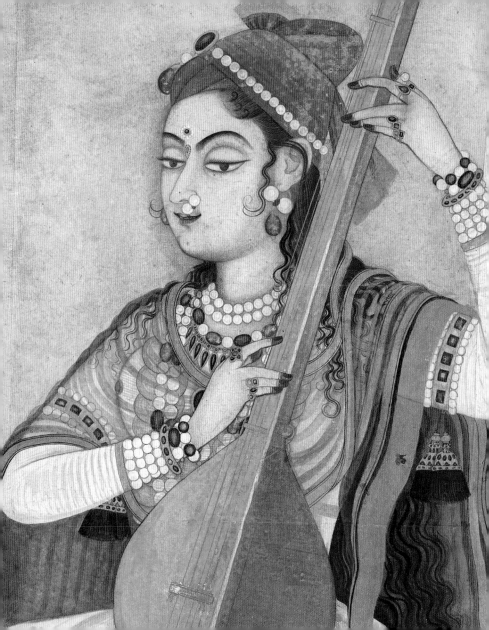

Fashion is song,

fashion is dance.

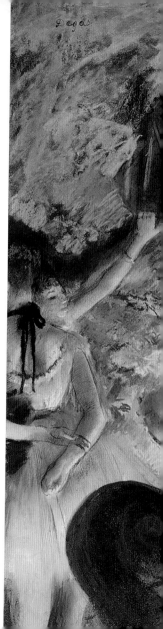

The Rehearsal Onstage (detail)

Edgar Degas, French, 1834–1917

Pastel over brush-and-ink drawing on thin cream-colored wove paper,
laid down on bristol board and mounted on canvas; 21 x 28$^{1}/_{2}$ in., 1874?

H. O. Havemeyer Collection, Bequest of Mrs. H. O. Havemeyer, 1929
29.100.39

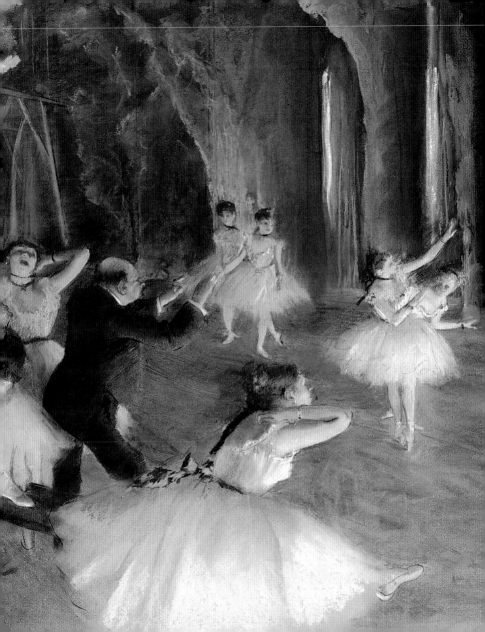

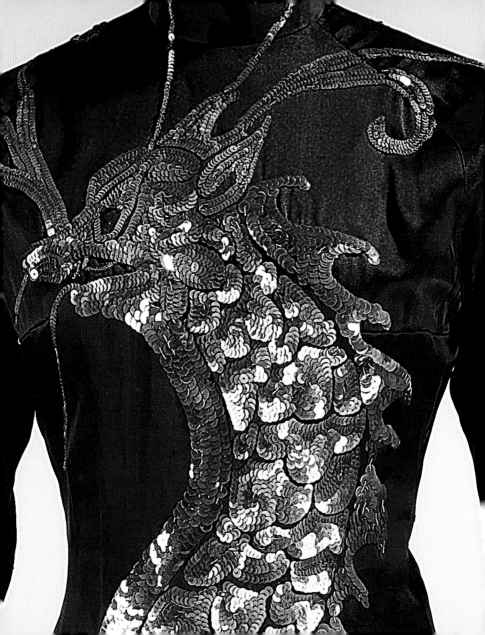

Fashion is sequins,

fashion is feathers.

Evening Dress (detail)
Yves Saint Laurent, French, 1936–2008
Silk, bird-of-paradise feathers; 1969–70
Gift of Baron Philippe de Rothschild, 1983 1983.619.1a, b

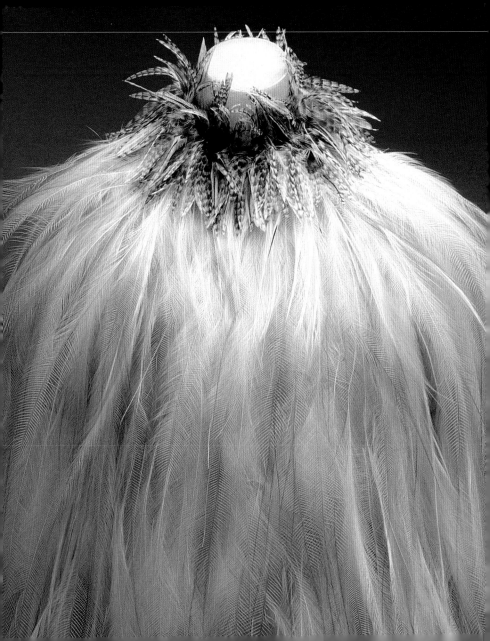

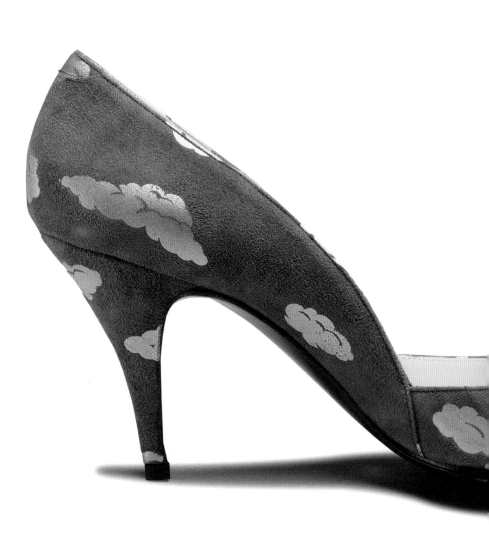

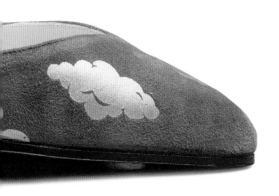

Fashion is fun,

Shoe
Armando Pollini, Italian
Leather, 1986
Gift of International Museum of Fashion, 1986 1986.258.3a, b

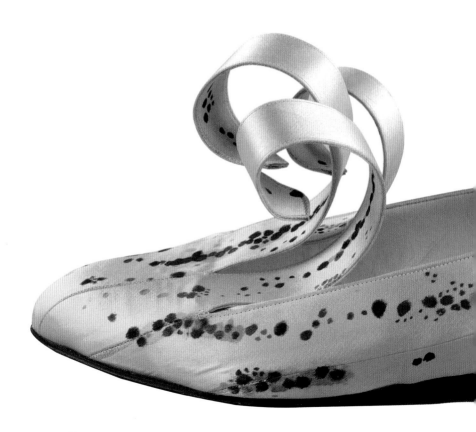

fashion is ironic.

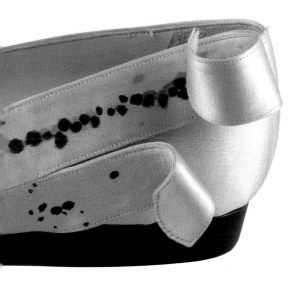

Shoe
Isabel Canovas, French, b. 1945
Silk, leather; spring / summer 1989
Gift of Isabel Canovas, 1989 1989.208.1a, b

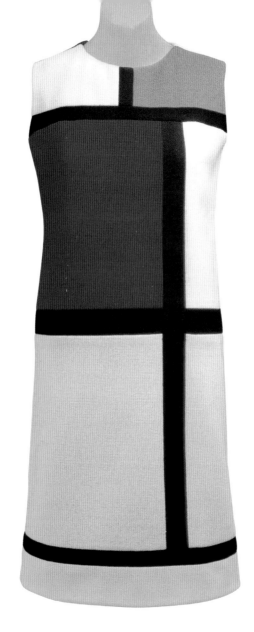

Fashion is art,

Dress

Yves Saint Laurent, French, 1938–2008

Wool, fall / winter 1965–66

Gift of Mrs. William Rand, 1969 C.I.69.23

fashion is music.

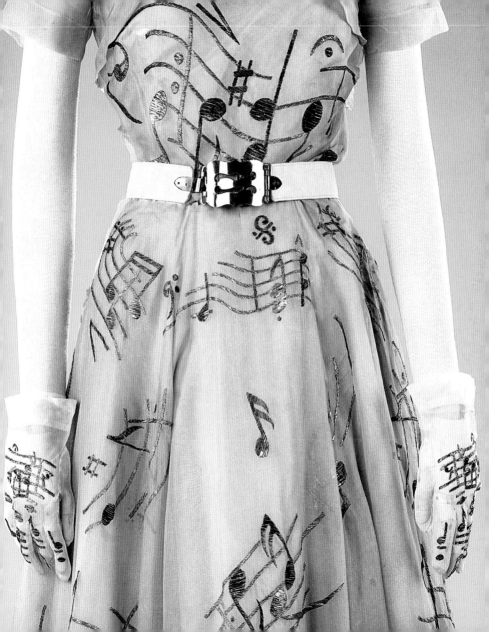

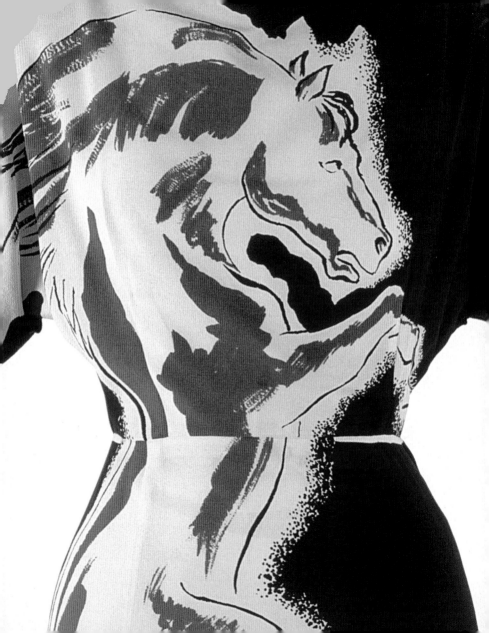

Fashion is figurative,

"Roan Stallion" Dress (detail)

Gilbert Adrian, American, 1903–1959

Silk, 1945

Gift of Gilbert Adrian, 1945 C.I.45.94

fashion is surreal.

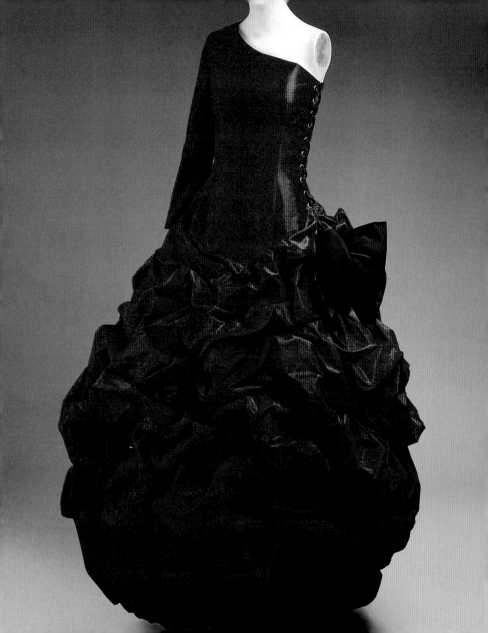

Fashion is over the top,

fashion is understated.

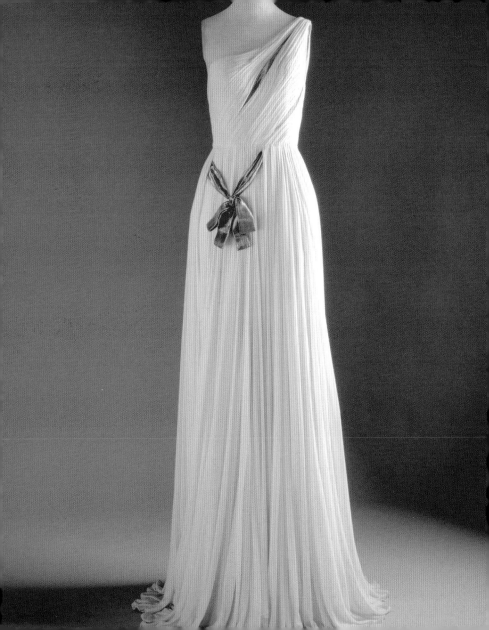

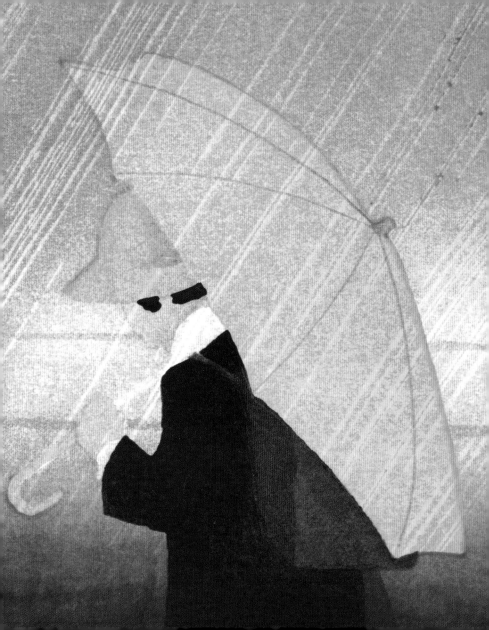

Fashion is practical,

fashion is improvised.

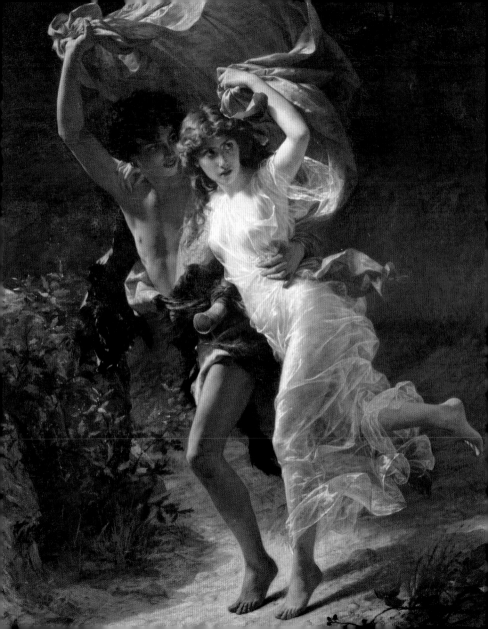

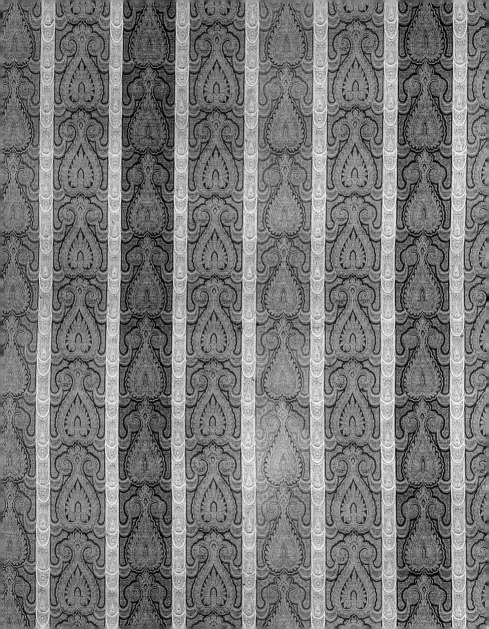

Fashion is paisley,

Shawl (detail)
French, 1860–75
Wool, silk
Brooklyn Museum Costume Collection at
The Metropolitan Museum of Art, Gift of the Brooklyn Museum, 2009;
Gift of Dr. and Mrs. Charles Parera, 1984 2009.300.3373

fashion is plaid.

Dress
American, 1858–60
Silk
Gift of Lee Simonson, 1938 C.I.38.23.56

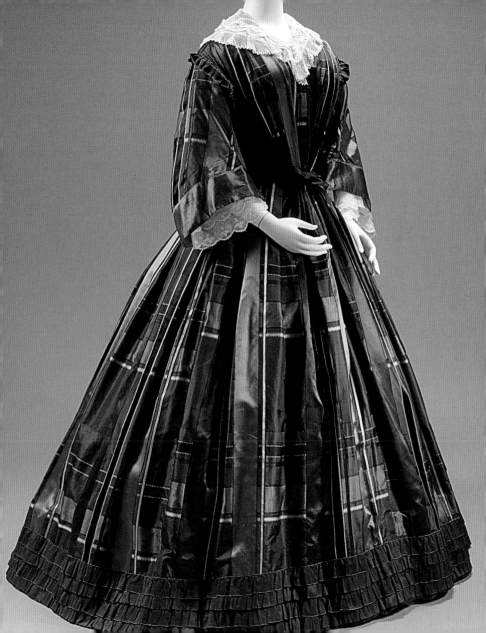

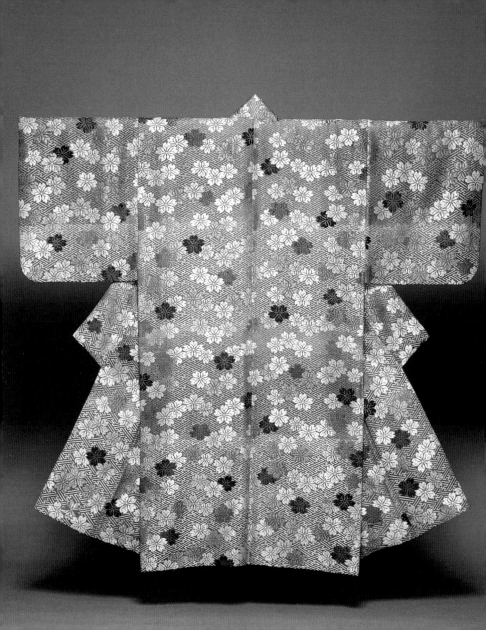

Fashion is theater,

Noh Costume (Karaori) with Cherry Blossoms and Fretwork
Japanese, Edo period (1615–1868)
Brocaded silk twill, first half of the 18th century
Rogers Fund, 1919 19.88.2

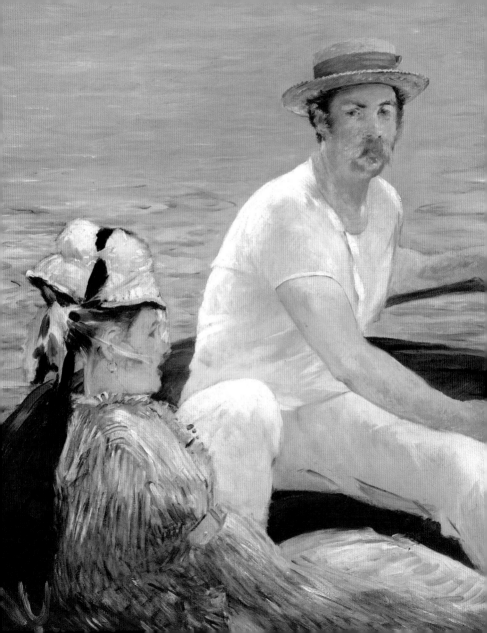

fashion is sport.

Fashion is a pump,

Pump
Isabel Canovas, French, b. 1945
Silk, sequins; fall / winter, 1988–89
Gift of Richard Martin, 1993 1993.34a, b

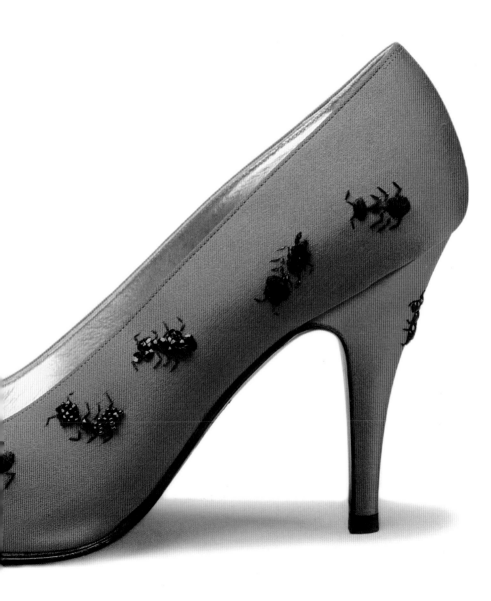

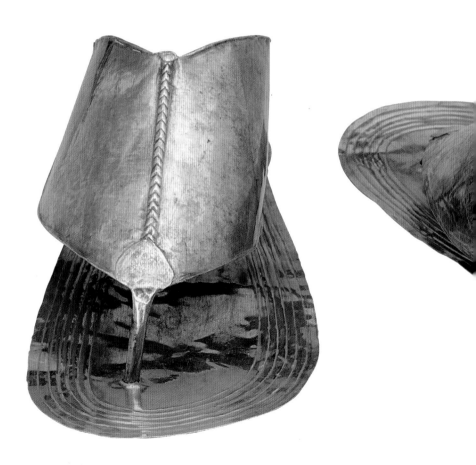

fashion is a sandal.

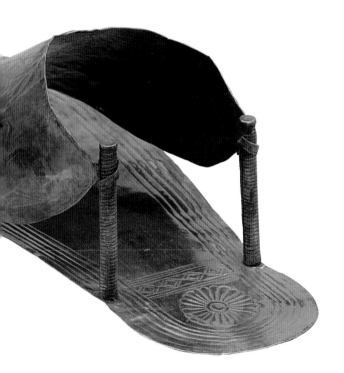

Sandal
Egyptian, Dynasty 18, ca. 1479–1425 B.C.
Gold
Fletcher Fund, 1926 26.8.148a, b

Fashion is shape,

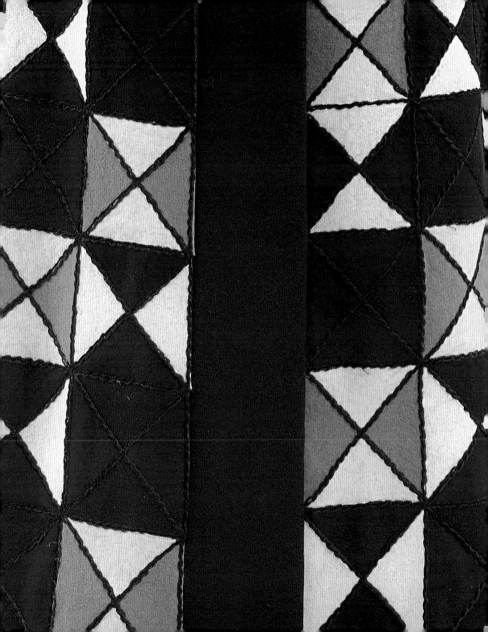

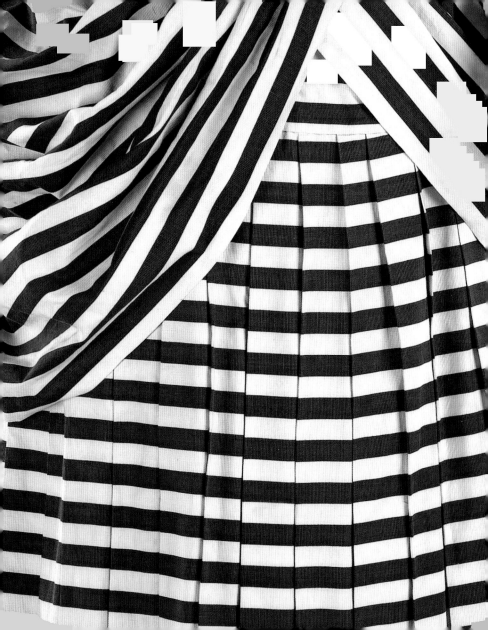

fashion is line.

Dress (detail)
American, 1885–88
Cotton, silk
Brooklyn Museum Costume Collection at
The Metropolitan Museum of Art, Gift of the Brooklyn Museum, 2009;
Gift of H. Dunscombe Colt, 1960 2009.300.2477a, b

Fashion is constructed,

"Four Leaf Clover" Evening Dress
Charles James, American (b. Great Britain), 1906–1978
Silk, 1953
Brooklyn Museum Costume Collection at
The Metropolitan Museum of Art, Gift of the Brooklyn Museum, 2009;
Gift of Josephine Abercrombie, 1953 2009.300.784

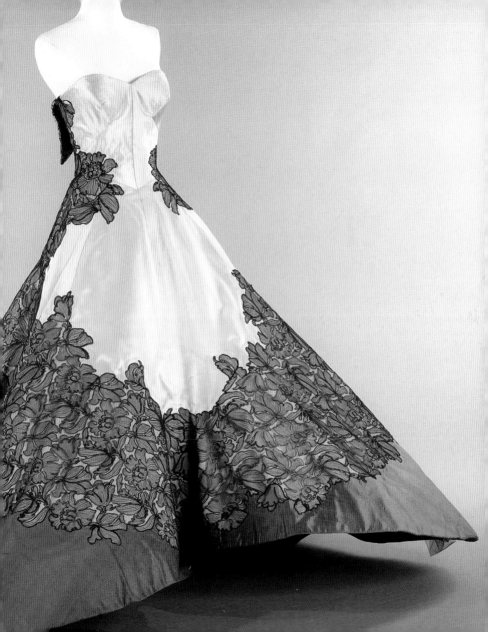

fashion is deconstructed.

"Creation" *Ensemble*

John Galliano, British (b. Spain), b. 1960

For House of Dior, French, founded 1947

Silk, synthetic, cotton, wool, plastic, metal, leather, pearl; fall / winter 2005–06

Purchase, The Dorothy Strelsin Foundation Inc. Gift, 2006 2006.22a–e

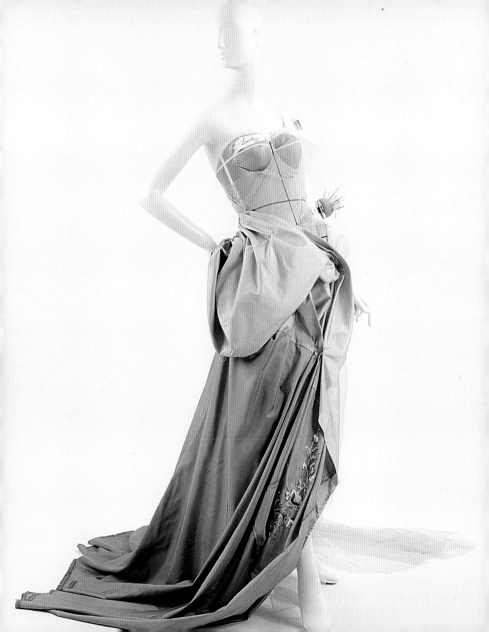

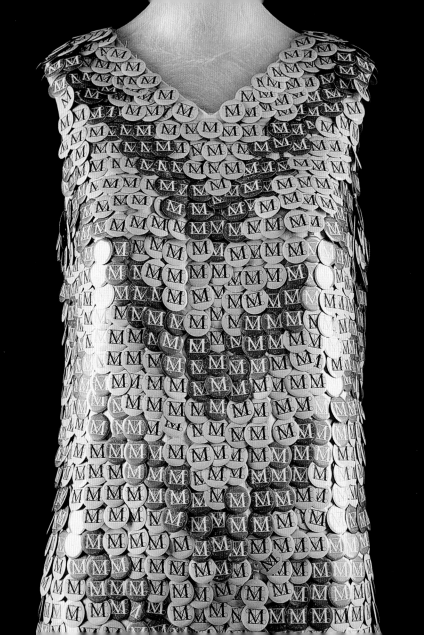

Fashion is found,

fashion is fantasy.

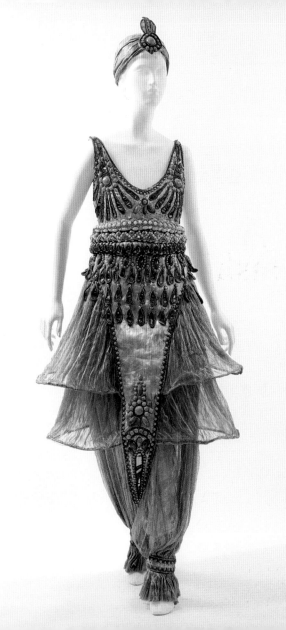

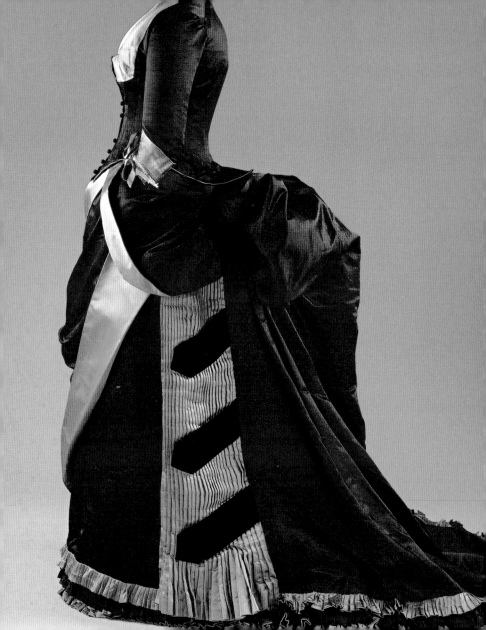

Fashion is a bustle,

fashion is a bikini.

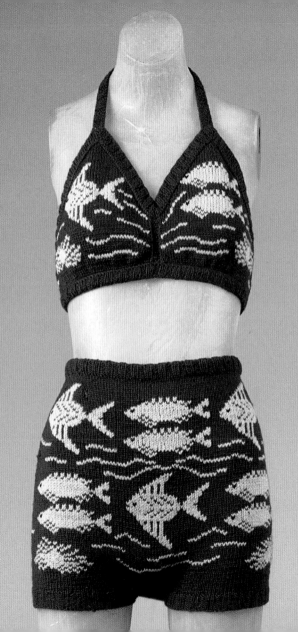

Fashion is coy,

fashion is brazen.

Moulin Rouge: La Goulue
Henri de Toulouse-Lautrec, French, 1864–1901
Lithograph printed in four colors on wove paper, 74 $^{13}/_{16}$ × 45 $^{7}/_{8}$ in., 1895
Harris Brisbane Dick Fund, 1932 32.88.12

MOULIN ROUGE CONCERT
MOULIN ROUGE BAL
MOULIN ROUGE TOUS LES SOIRS
LA GOULUE

TOUS LES SOIRS

MOULIN ROUGE

les Mercredis et Samedis

BAL MASQUÉ

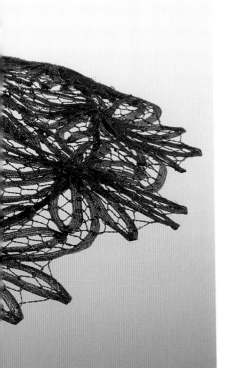

Fashion is on the head,

fashion is on the feet.

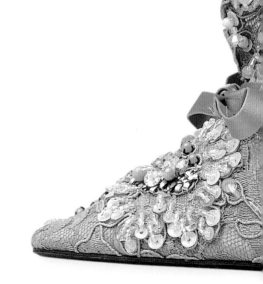

Boot

Roger Vivier, French, 1913–1998

For House of Dior, French, founded 1947

Silk, leather, cotton, plastic, glass; 1957

Gift of Valerian Stux-Rybar, 1980 1980.597.25

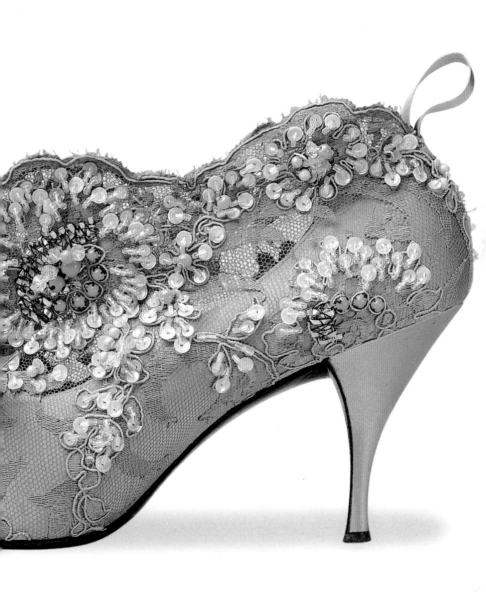

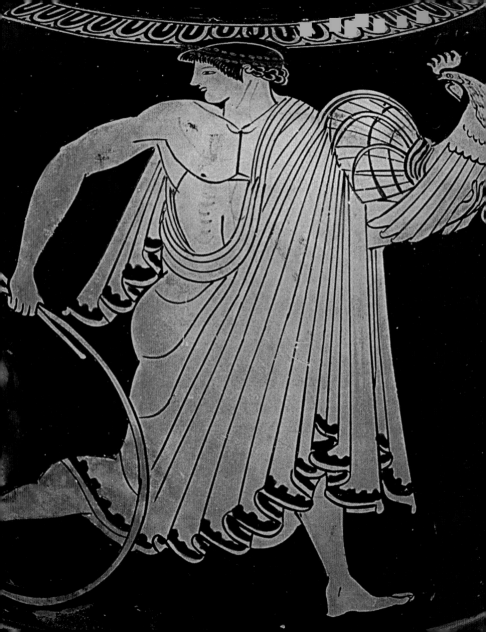

Fashion is a toga,

fashion is a fig leaf.

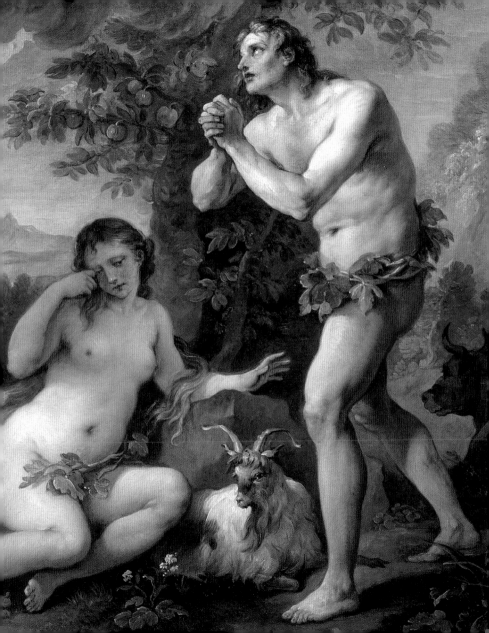

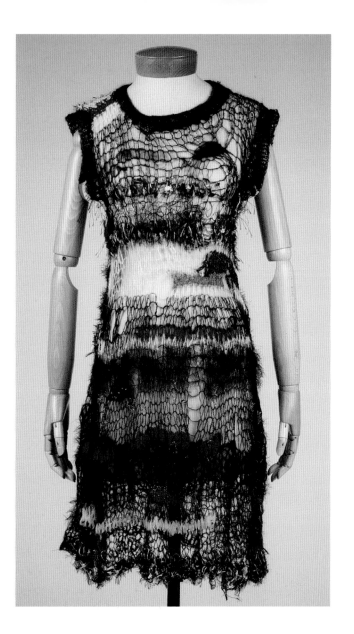

Fashion is punk,

Ensemble

Rodarte, American, founded 2004

Wool, silk, synthetic, leather, metal; fall / winter 2008–09

Purchase, Gilles Bensimon Inc. Gift, 2009 2009.422a–e

fashion is polite.

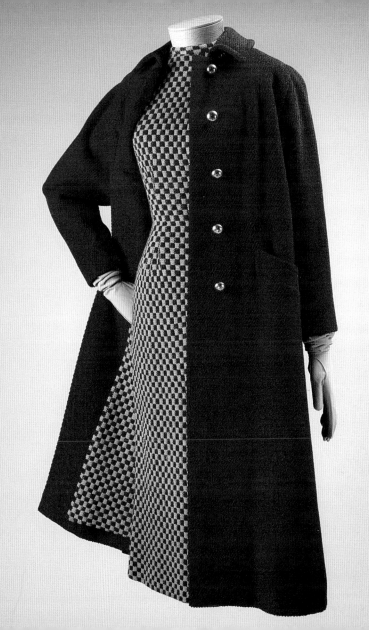

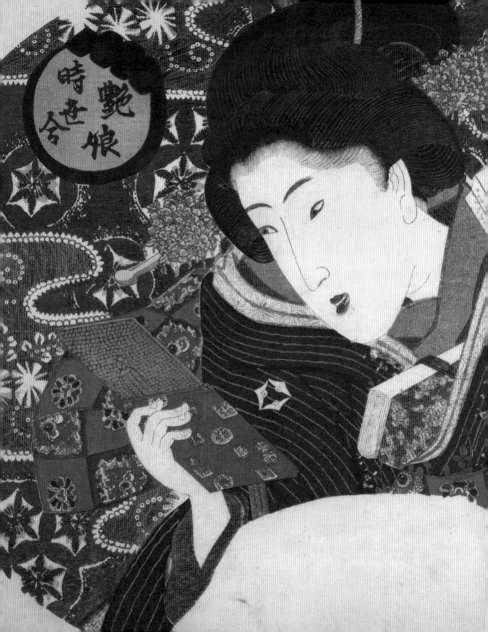

艶娘
時世合

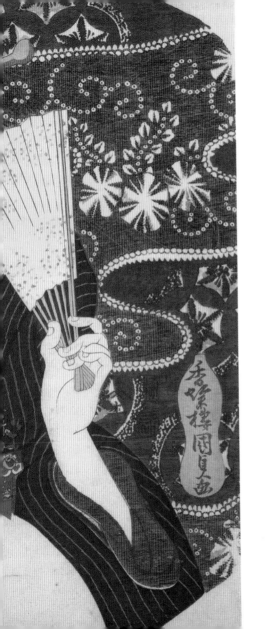

Fashion is printed,

Competition of Contemporary Fashions:
Sexy Beauty (detail)
Utagawa Kunisada, Japanese, 1786–1864
Polychrome woodblock print; ink and colors
on paper, 11 3/8 × 8 3/4 in., 19th century
Bequest of William S. Lieberman, 2005 2007.49.267

fashion is photographed.

[*Fashion Photograph for Lord and Taylor*] (detail)
George Platt Lynes, American, 1907–1955
Gelatin silver print, $9^7/_{16} \times 7^7/_{16}$ in., 1940
David Hunter McAlpin Fund, 1941 41.65.2
© Estate of George Platt Lynes

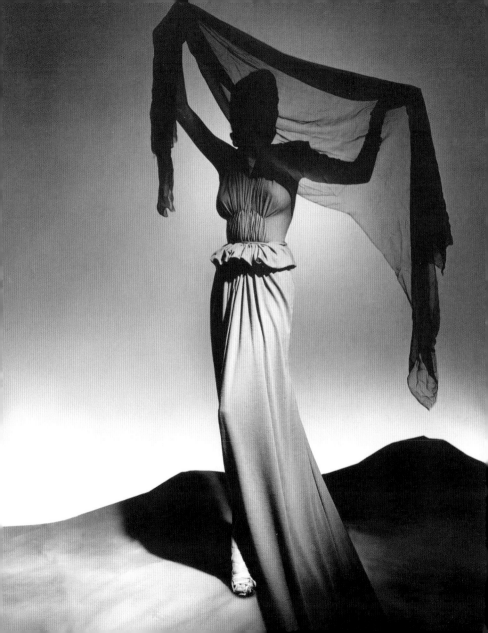

Fashion is history,

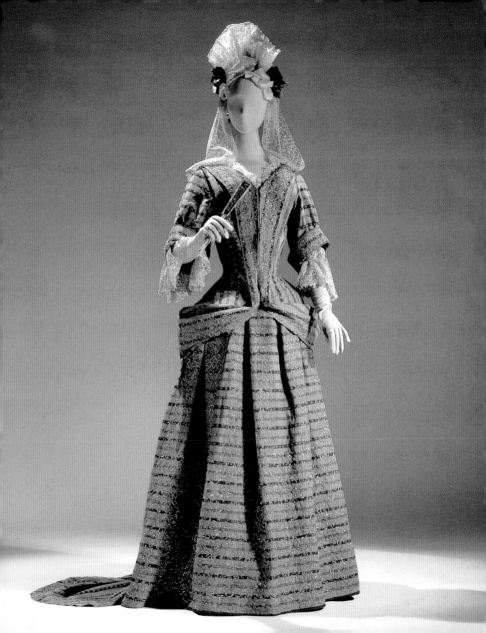

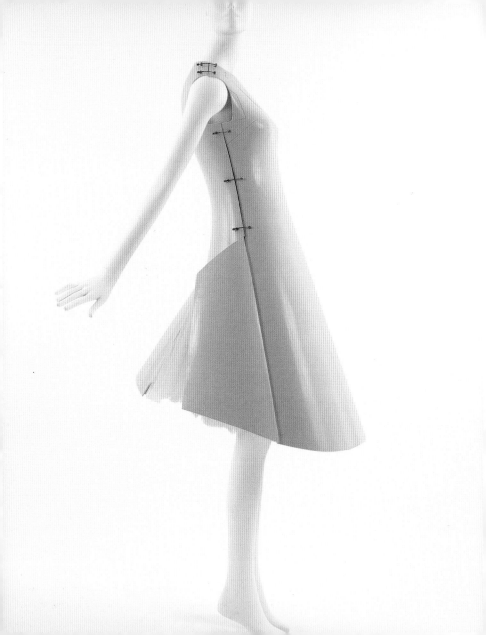

fashion is the future.

"Remote Control" Ensemble

Hussein Chalayan, British, b. 1970

Fiberglass, metal, cotton, synthetic; spring / summer 2000, edition 2005

Purchase, Friends of The Costume Institute Gifts, 2006 2006.251a–c

Fashion is elegance,

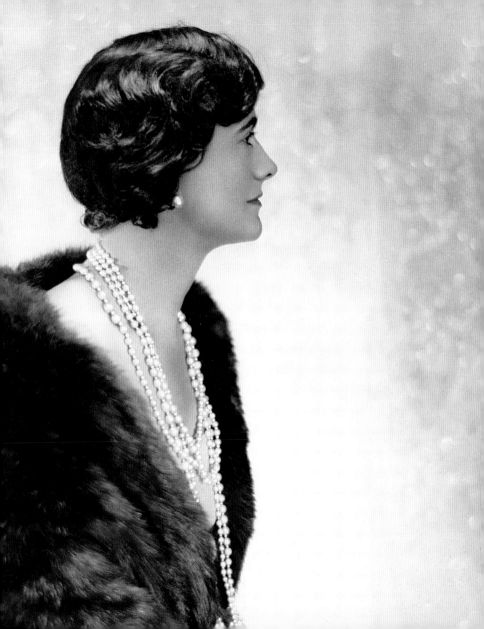

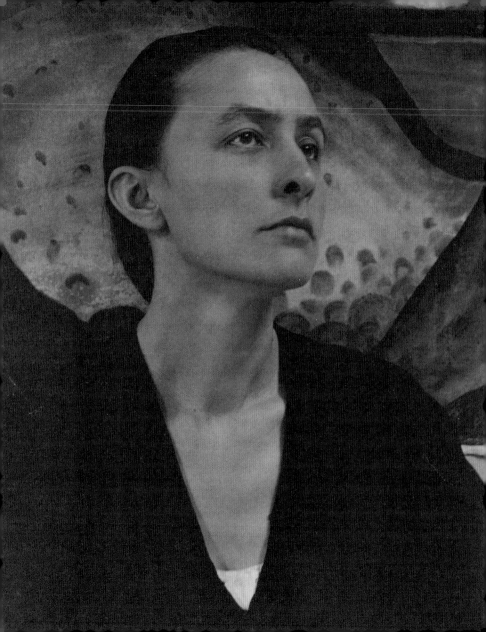

fashion is confidence.

Fashion is embroidery,

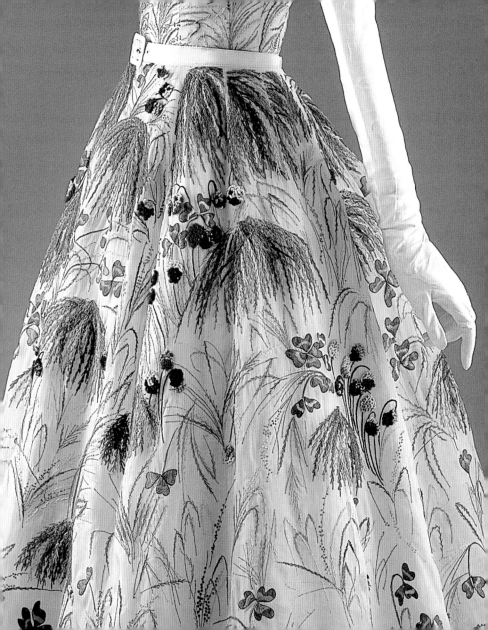

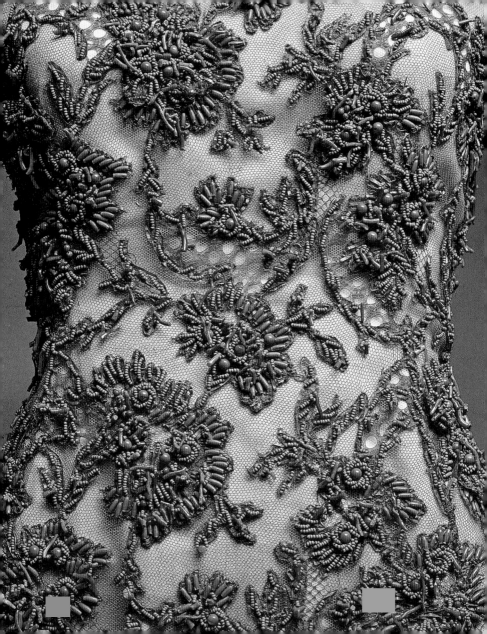

fashion is beads.

Fashion is
on the street,

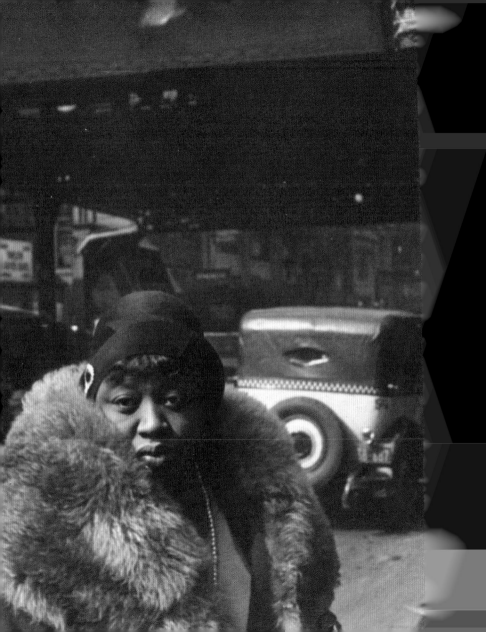

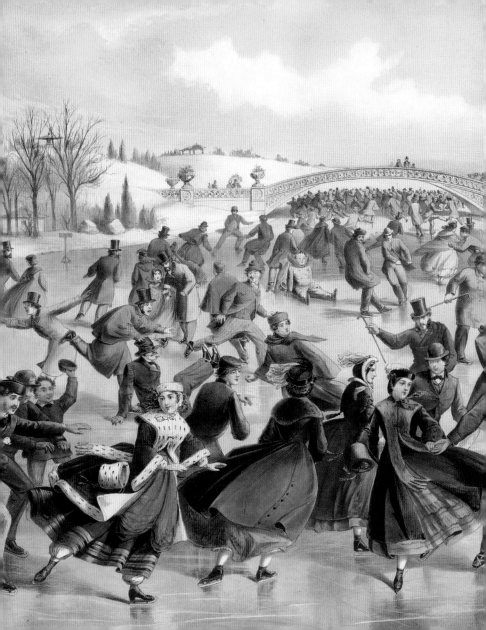

fashion is on the ice.

Central Park, Winter: The Skating Pond (detail)
Lyman W. Atwater, American, 1835–1891
After a painting by Charles Parsons, American, 1821–1910
Published and printed by Currier and Ives, American, active 1837–1907
Hand-colored lithograph, 18¹/8 x 26⁹/16 in., 1862
Bequest of Adele S. Colgate, 1962 63.550.266

Fashion is organic,

Ceremonial Skirt (Ntchak) (detail)

Kuba peoples, Bushoong group, Democratic Republic of the Congo, late 19th century

Raffia palm fiber, natural dyes

Rogers Fund, 2004 2004.254

fashion is synthetic.

Scarf (detail)

Fiorucci, Italian, founded 1962

Polyester, acetate, cotton, nylon; mid-1970s

Gift of Barbara and Gregory Reynolds, 1984 1984.598.71a–m

Fashion is country,

fashion is rock and roll.

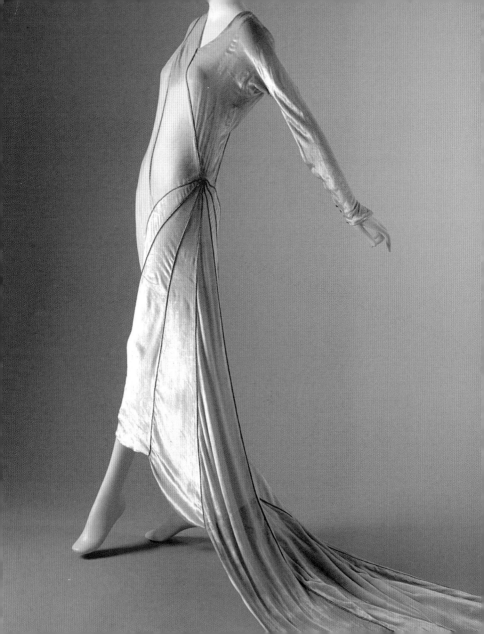

Fashion is a bias cut,

Wedding Ensemble

Madeleine Vionnet, French, 1876–1975

Silk, 1929

Gift of Mrs. Ivan Heukelom Winn, 1974 1974.261a–c

fashion is an A-line.

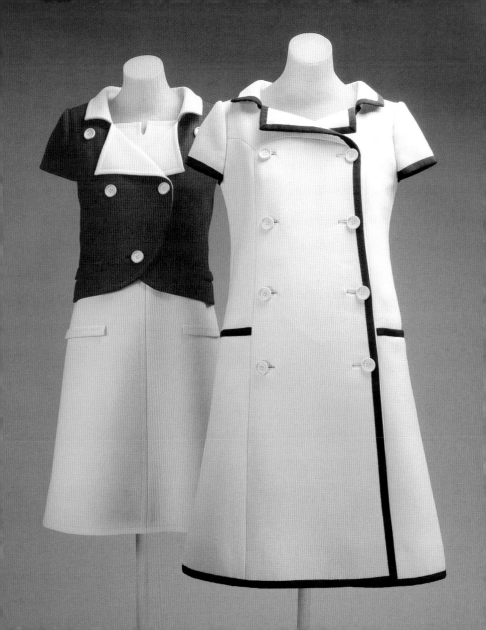

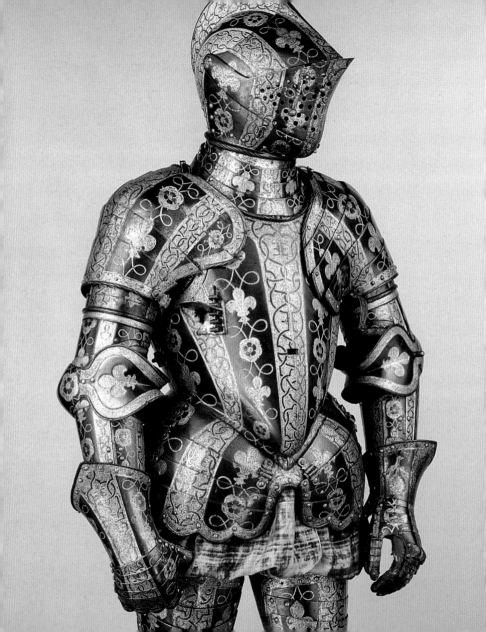

Fashion is armored,

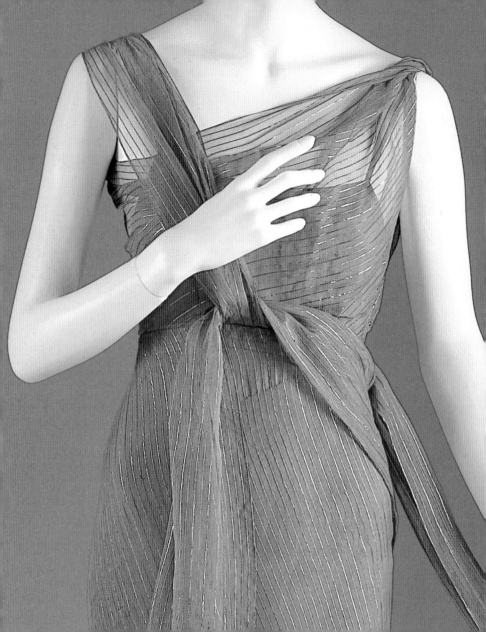

fashion is sheer.

Evening Ensemble
Elsa Schiaparelli, Italian, 1890–1973
Silk, 1939
Gift of Mrs. Harrison Williams, Lady Mendl,
and Mrs. Ector Munn, 1946 C.I.46.4.10a–c

Fashion is color blocks,

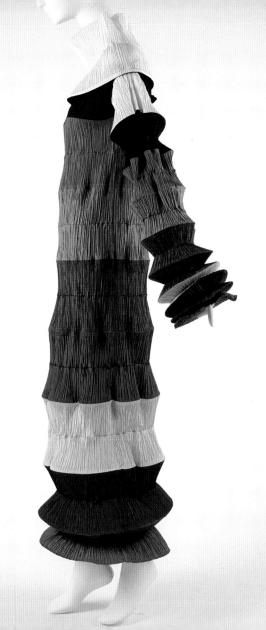

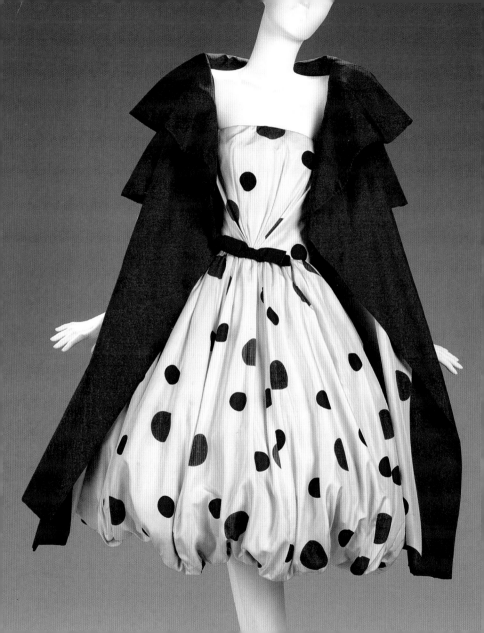

fashion is polka dots.

Evening Ensemble
Arnold Scaasi, American, b. 1931
Silk, 1961
Brooklyn Costume Collection at
The Metropolitan Museum of Art,
Gift of the Brooklyn Museum, 2009;
Gift of Kay Kerr, 1965 2009.300.391a, b

Fashion is landscape,

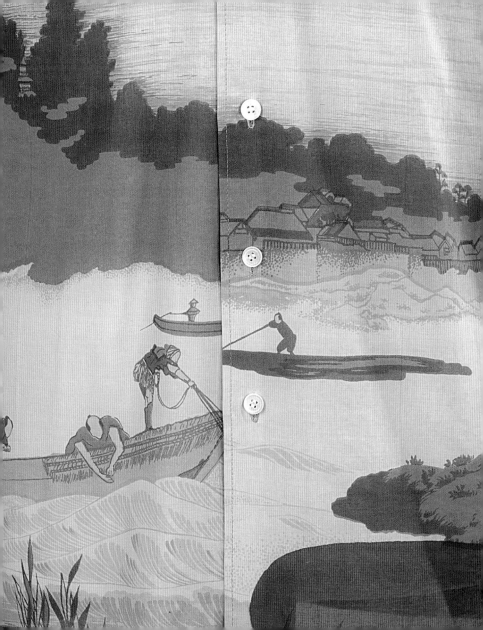

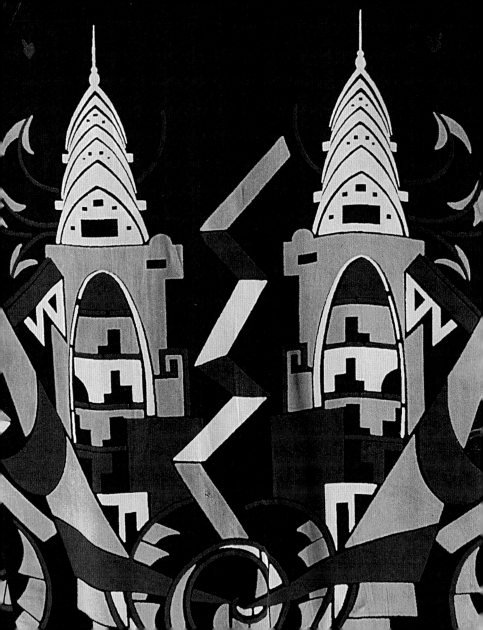

fashion is cityscape.

Ensemble (detail)

American or European, 1933–37

Rayon

The Jacqueline Loewe Fowler Costume Collection,

Gift of Jacqueline Loewe Fowler, 1996 1996.135.2a–c

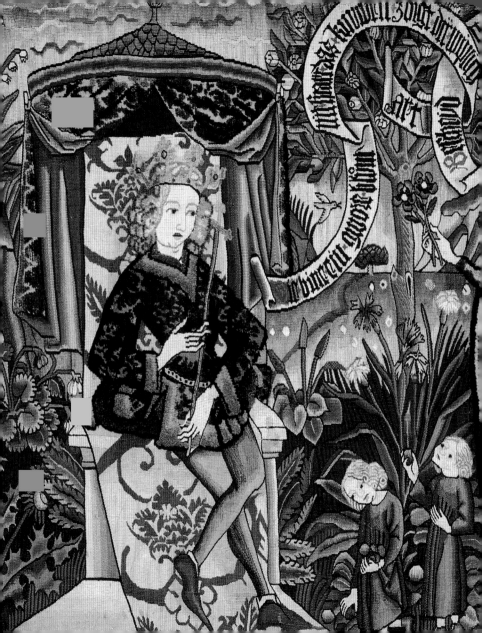

Fashion is medieval,

Two Riddles of the Queen of Sheba (detail)

German (Strasbourg), ca. 1490–1500

Linen warp; wool, linen and metallic wefts; 31 1/2 × 40 in.

The Cloisters Collection, 1971 1971.43

fashion is Rococo.

The Love Letter (detail)
Jean Honoré Fragonard, French, 1732–1806
Oil on canvas, 32³/8 x 26³/8 in., early 1770s
The Jules Bache Collection, 1949 49.7.49

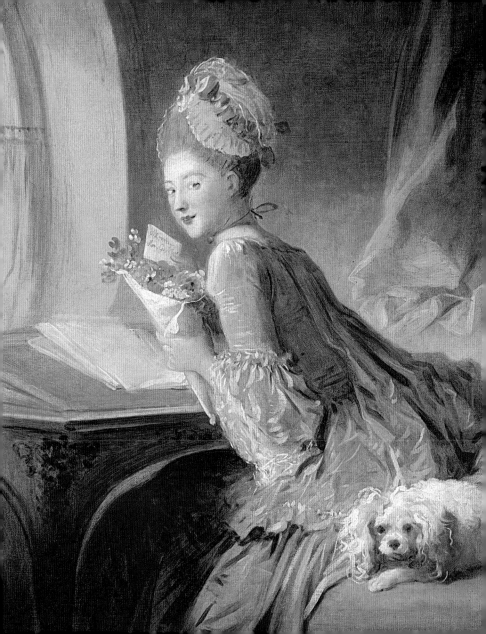

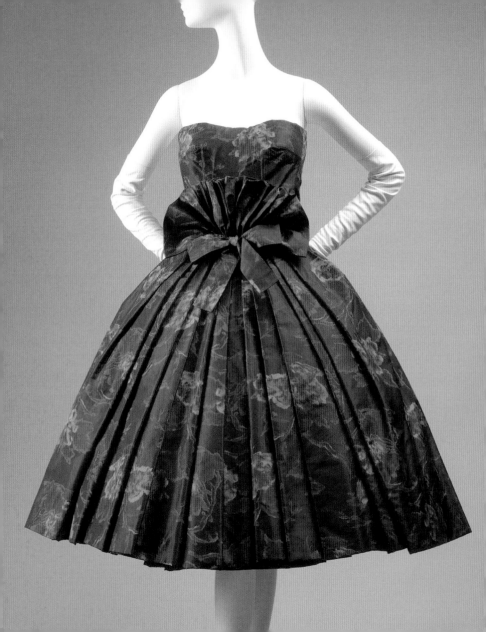

Fashion is pleated,

"Eventail" Cocktail Dress
Christian Dior, French, 1905–1957
Silk, fall / winter 1956–57
Gift of Muriel Rand, 1963 C.I.63.36a–c

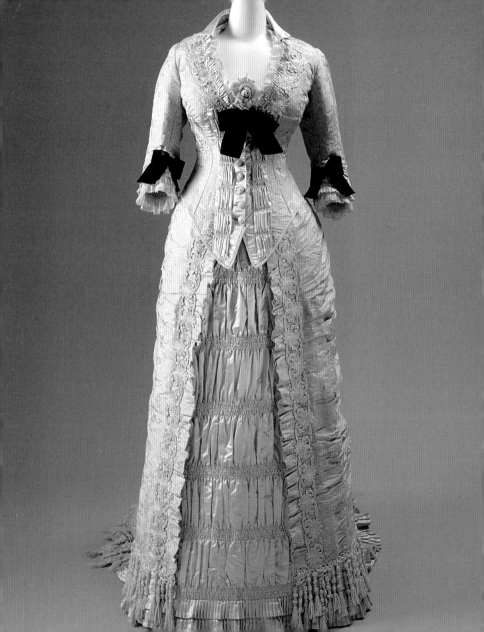

fashion is ruched.

Dinner Dress (detail)

Mon. Vignon, French

Silk, glass; 1875–78

Gift of Mary Pierrepont Beckwith, 1969 C.I.69.14.12a, b

Fashion is a fichu,

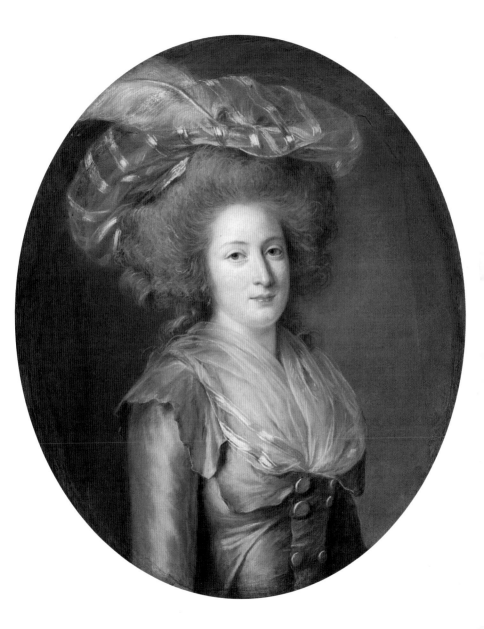

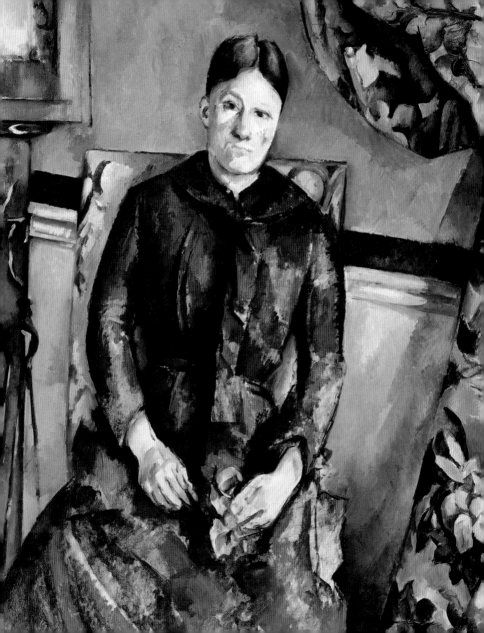

fashion is a shawl collar.

Fashion is work,

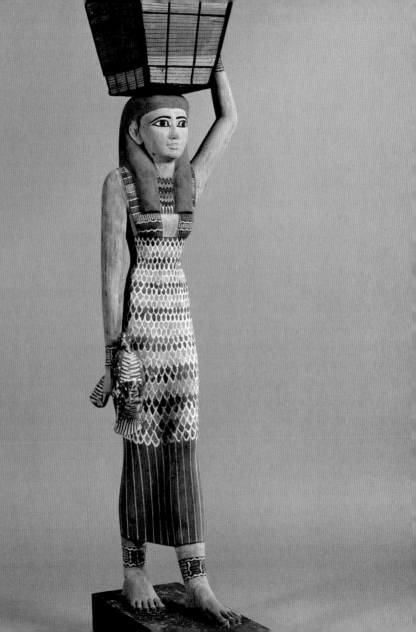

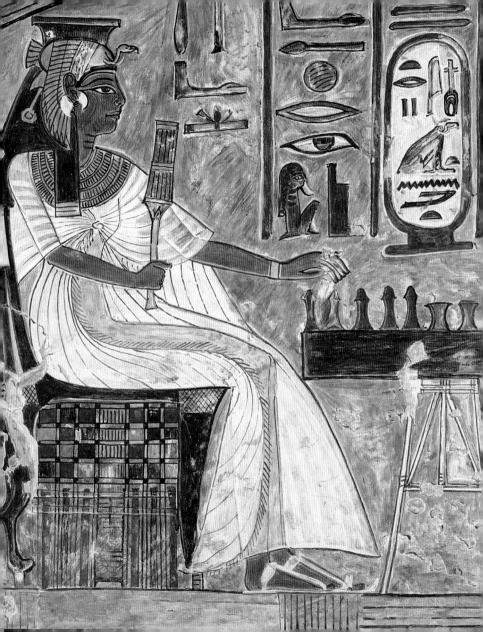

fashion is play.

Fashion is pristine,

Wedding Dress

American, 1840–42

Silk

Brooklyn Museum Costume Collection at

The Metropolitan Museum of Art, Gift of the Brooklyn Museum, 2009;

Gift of Claire Lorraine Wilson, 1942 2009.300.668

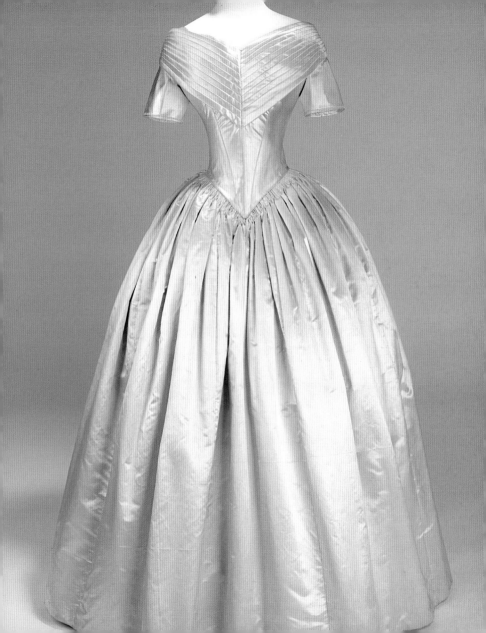

fashion is imperfect.

Dress (left)
John Paul Gaultier, French, b. 1952
Acrylic, fall / winter 1993–94
Purchase, Gifts from various donors, 1994 1994.9.3

Dress (right)
Yohji Yamamoto, Japanese, b. 1943
Cotton, spring / summer 1993
Gift of Richard Martin, 1993 1993.96

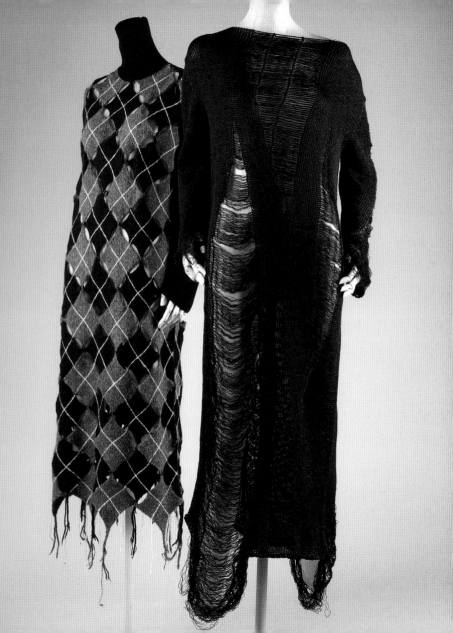

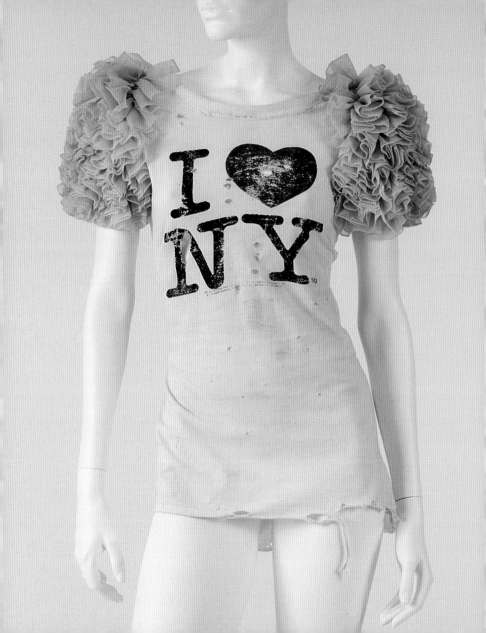

Fashion is chaos,

"I Love New York" Dress
Miguel Adrover, Spanish, b. 1965
Cotton, cotton / silk blend, synthetic; 2000
Gift of Miguel Adrover, 2005 2005.44.2

fashion is couture.

Maria-Luisa (dite Coré)
John Galliano, British, b. 1960
For House of Dior, French, founded 1947
Silk, synthetic, wool, metal, glass;
spring / summer 1998
Gift of Christian Dior Couture Paris, 1999
1999.494a–h

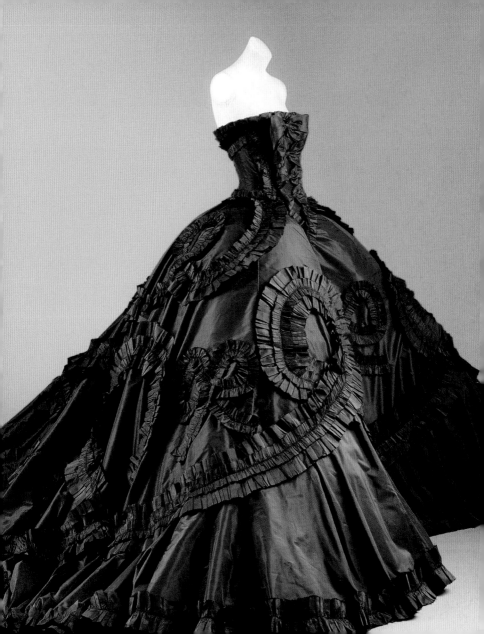

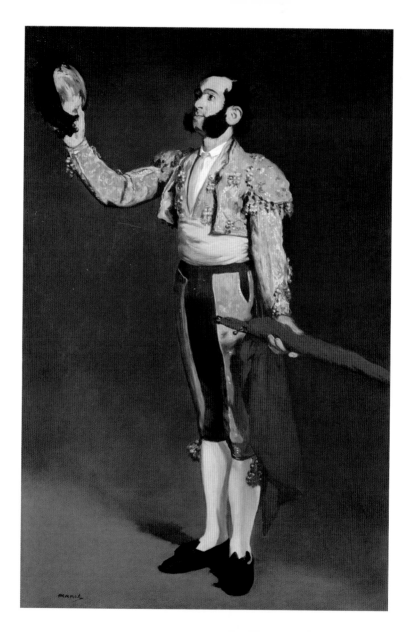

Fashion is a bolero,

fashion is a cape.

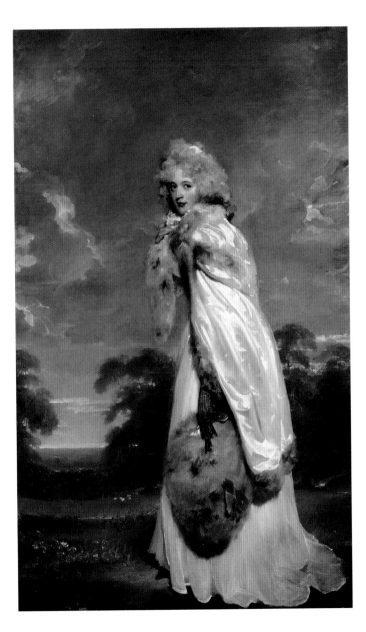

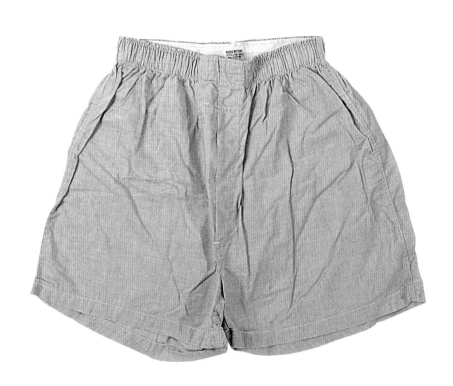

Fashion is boxers,

Boxer Shorts

Brooks Brothers, American, founded 1818

Cotton, 1960s

Gift of Marvin B. Patterson (Mrs. Jefferson Patterson), 1978 1978.582.176

fashion is briefs.

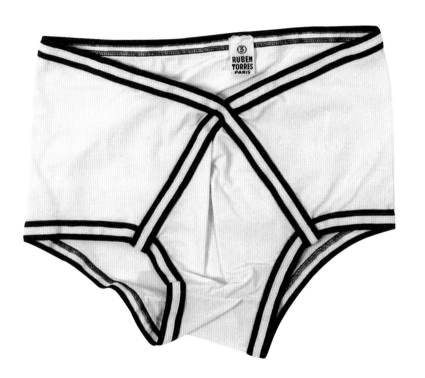

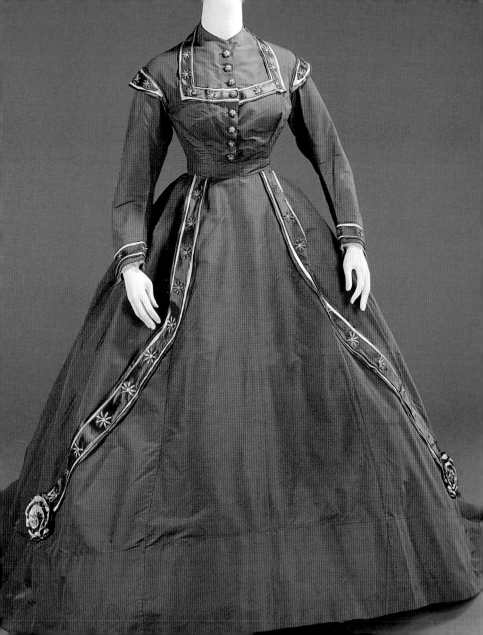

Fashion is a hoopskirt,

fashion is a pencil skirt.

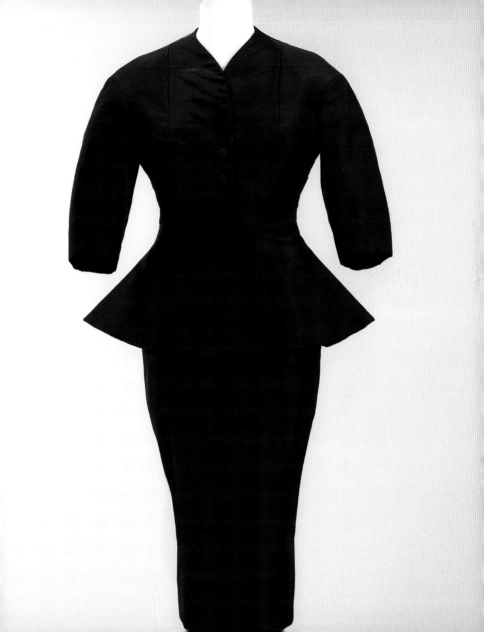

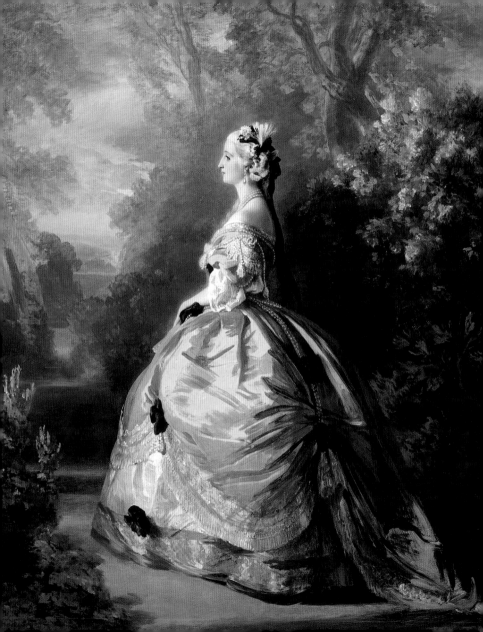

Fashion is regal,

The Empress Eugénie (Eugénie de Montijo, 1826–1920, Condesa de Teba) (detail)
Franz Xaver Winterhalter, German, 1805–1873
Oil on canvas, 36 1/2 × 29 in., 1854
Purchase, Mr. and Mrs. Claus von Bülow Gift, 1978 1978.403

fashion is uniform.

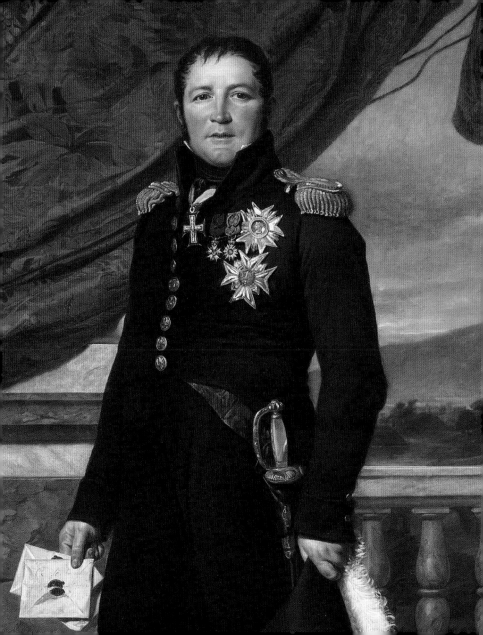

Fashion is quilted,

Purse

Karl Lagerfeld, French, b. 1938

For House of Chanel, French, founded 1913

Leather, metal; late 1980s–early 1990s

Bequest of Joanne Toor Cummings, 1995 1996.336.10

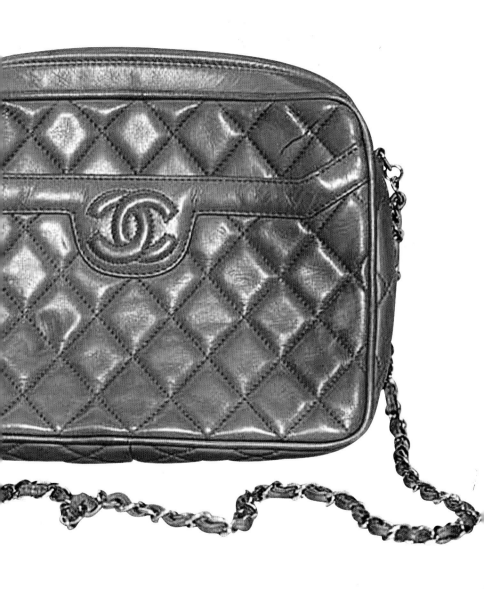

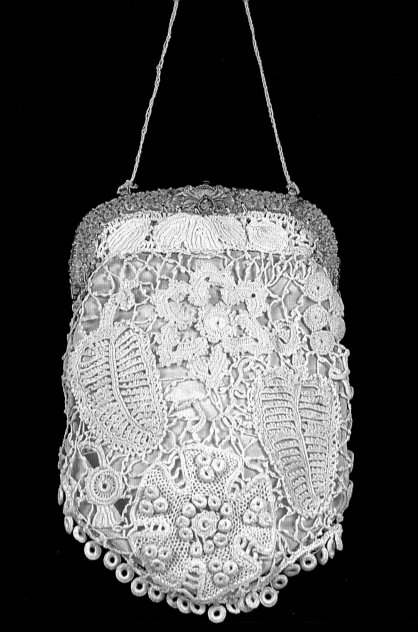

Fashion is crocheted.

Bag
American, 1885–99
Cotton, silk, metal
Brooklyn Museum Costume Collection at
The Metropolitan Museum of Art, Gift of the Brooklyn Museum, 2009;
Ella C. Woodward Memorial Fund, 1922 2009.300.4059

Fashion is fitted,

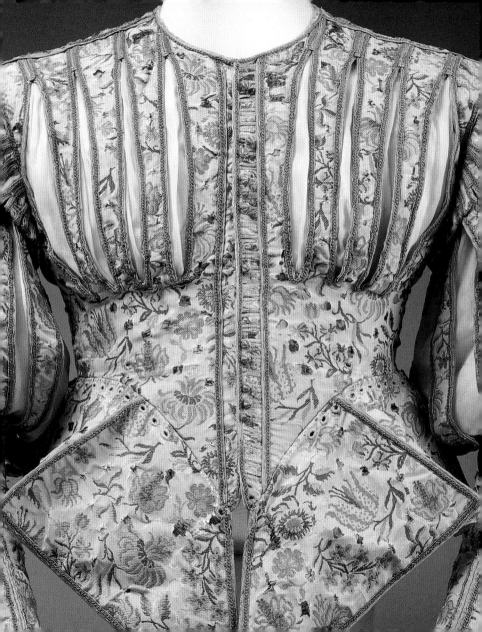

fashion is free.

Tunic

Peru (Moche or Wari), 7th–9th century

Camelid hair, cotton

Bequest of Jane Costello Goldberg, from the Collection of Arnold I. Goldberg, 1986 1987.394.706

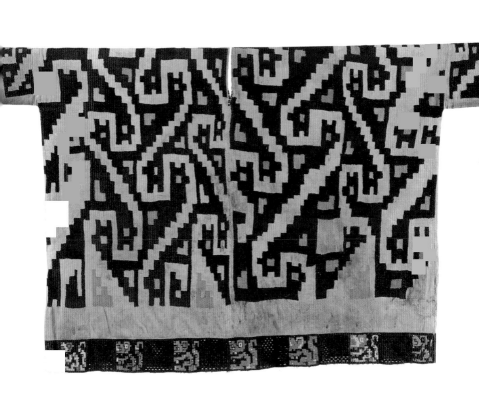

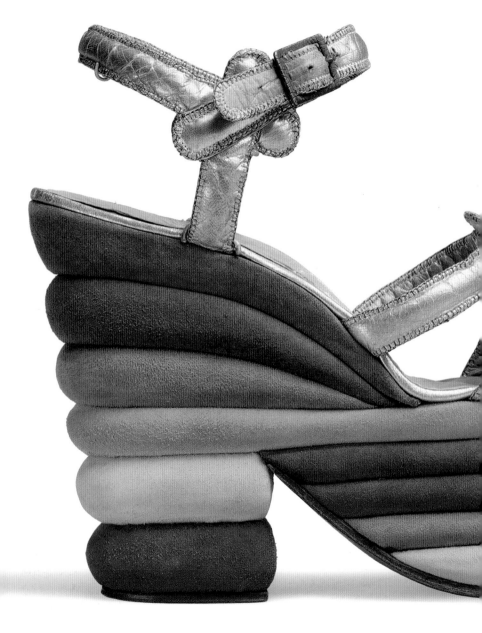

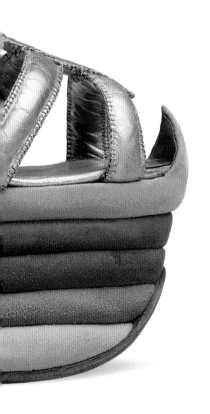

Fashion is platforms,

fashion is stilettos,

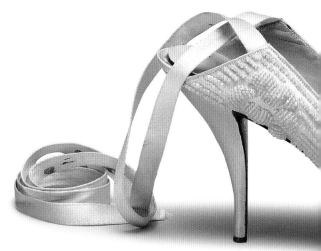

Evening Shoes
Roger Vivier, French, 1913–1998
For House of Dior, French, founded 1947
Silk, leather, glass; ca. 1957
Gift of Valerian Stux-Rybar, 1979 1979.472.17a, b

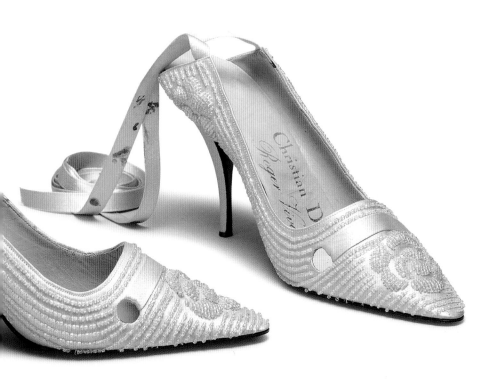

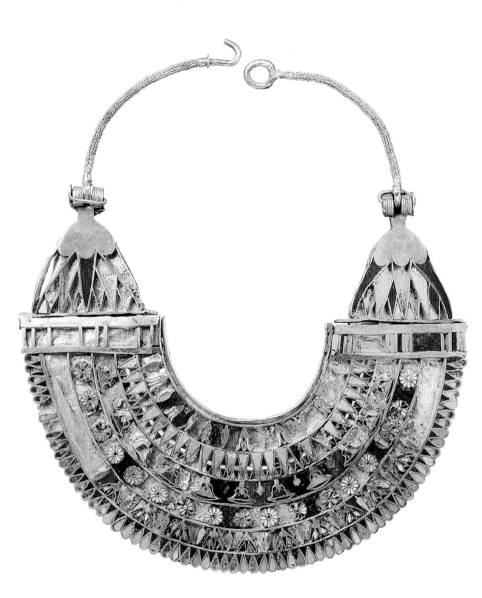

Fashion is a collar,

fashion is a cuff.

Fashion is detailed,

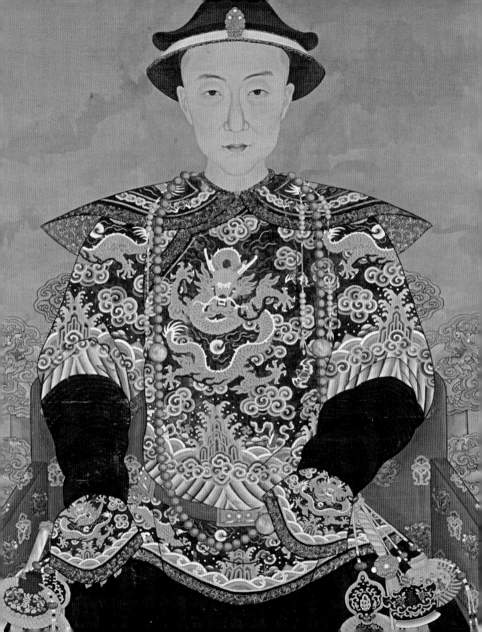

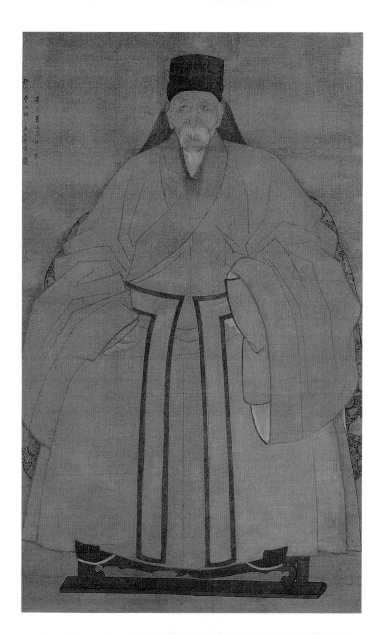

fashion is simple.

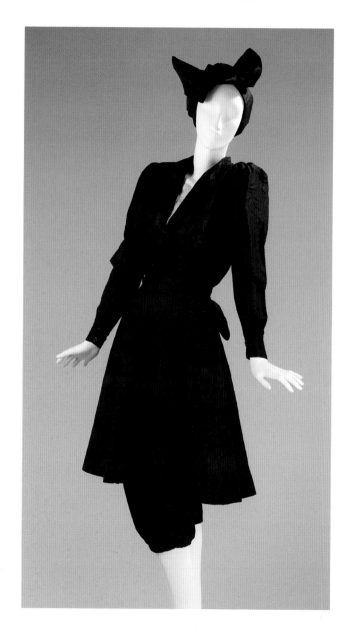

Fashion is a day at the beach,

fashion is a walk in the park.

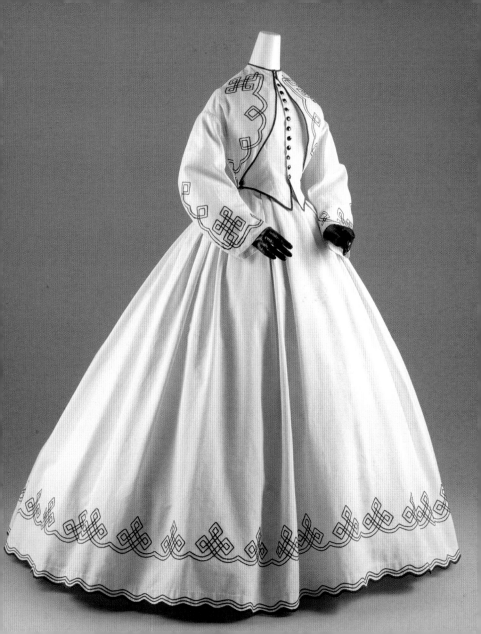

Fashion is illustrated,

fashion is sculpted.

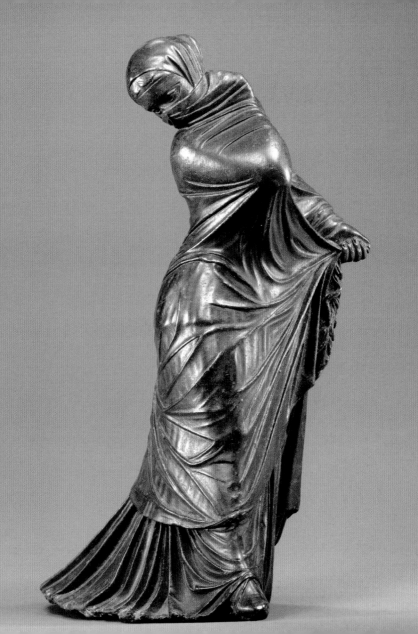

Fashion is a tunic,

"Shah Jahan on Horseback" (detail)
Folio from the *Shah Jahan Album*
Painting by Payag, India, active ca. 1591–1658
Ink, opaque watercolor, and gold on paper, 15⁵/₁₆ × 10¹/₈ in., ca. 1630
Purchase, Rogers Fund and The Kevorkian Foundation Gift, 1955 55.121.10.21

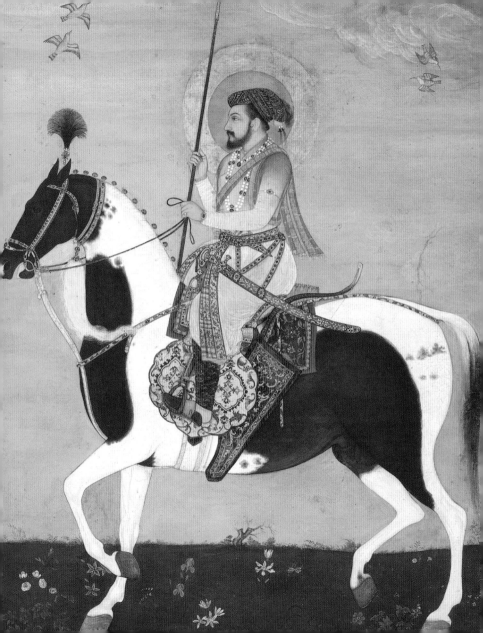

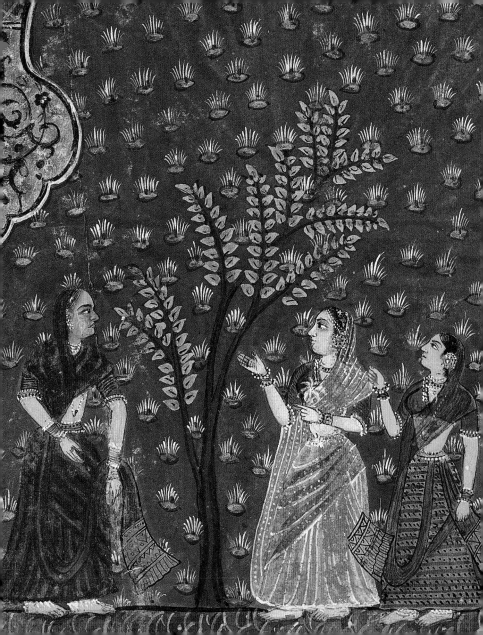

fashion is a sari.

Fashion is safe,

Suit

Gabrielle "Coco" Chanel, French, 1883–1971

Wool, silk, metal; ca. 1962

Brooklyn Museum Costume Collection at The Metropolitan Museum of Art,

Gift of the Brooklyn Museum, 2009; Gift of Jane Holzer, 1977 2009.300.525a–c

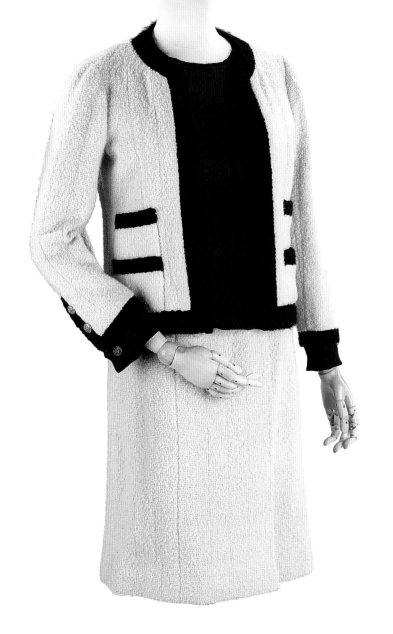

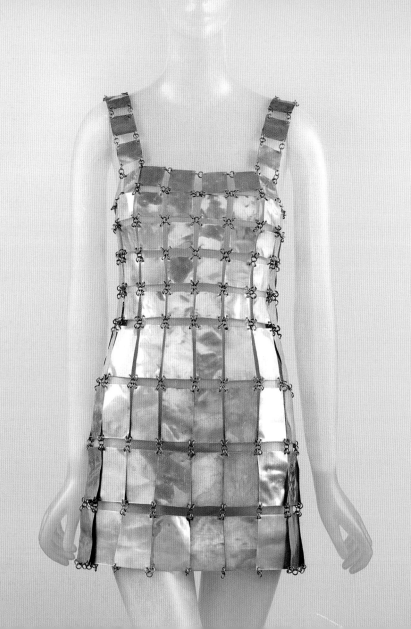

fashion is risk.

Dress

Paco Rabanne, French (b. Spain), 1934

Metal, 1967

Purchase, Gould Family Foundation Gift,

in memory of Jo Copeland, 2008 2008.305

Fashion is reflection,

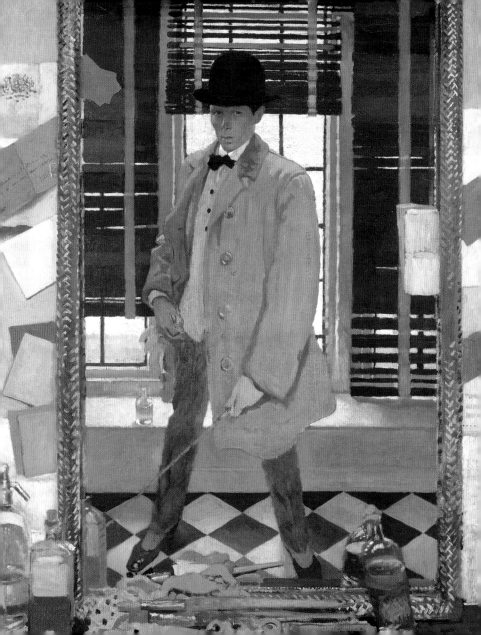

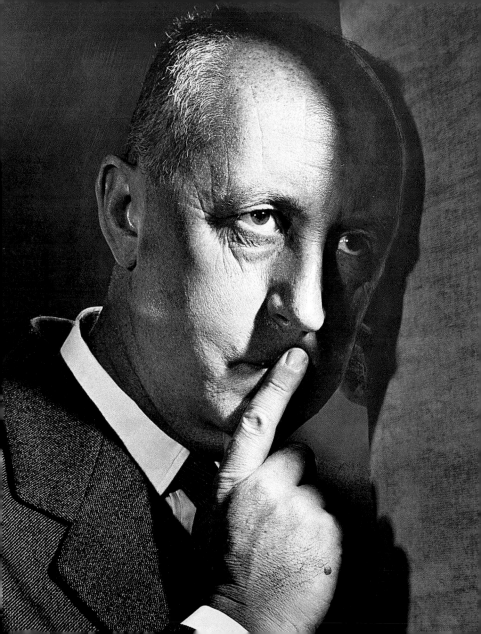

fashion is vision.

Fashion is cinched,

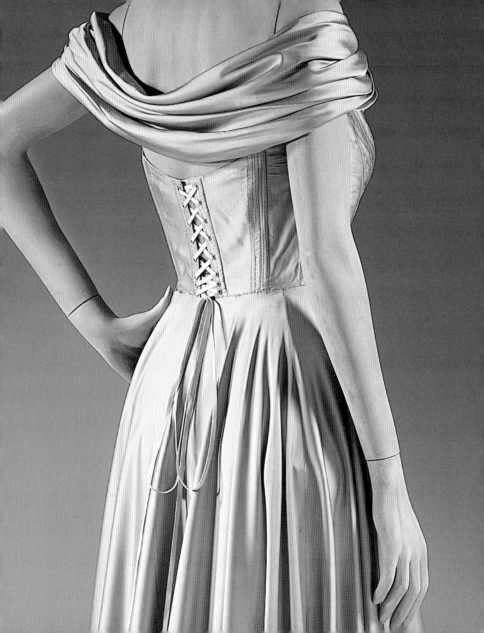

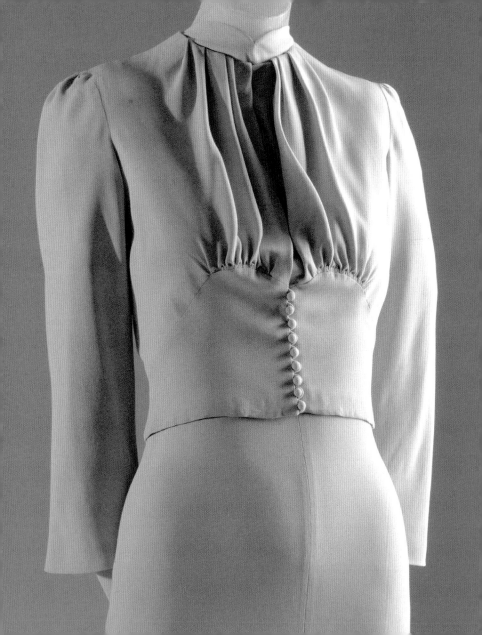

fashion is buttoned.

Fashion is black and white,

Dress
Jeanne Lanvin, French, 1867–1946
Silk, wool; ca. 1924
Gift of Mrs. Carter Marshall Braxton, 1980 1980.92.1a–c

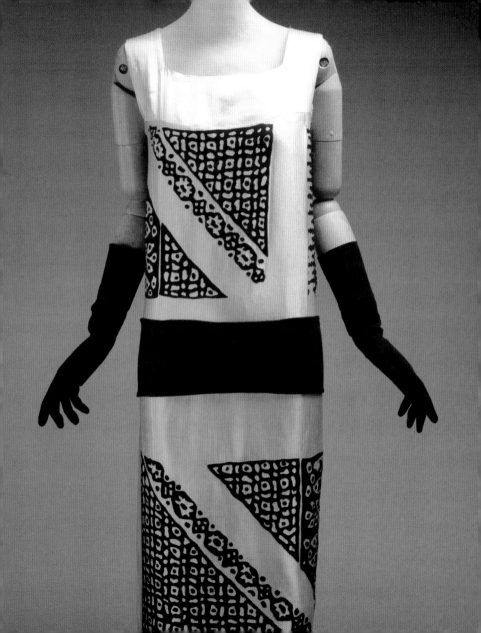

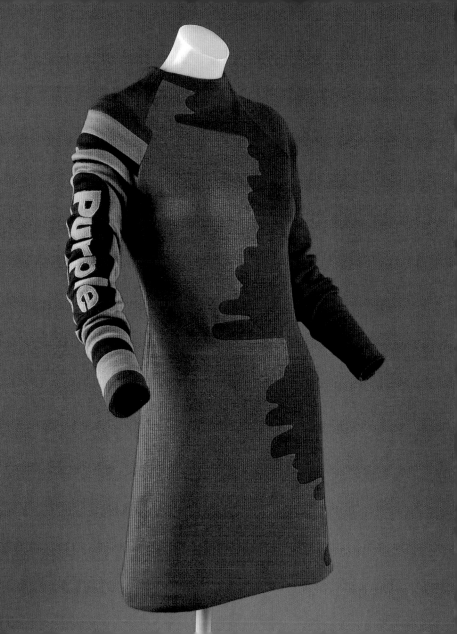

fashion is color.

Dress

Christian Francis Roth, American, b. 1969

Wool, ca. 1990

Gift of Amy Fine Collins, 1994 1994.490.5

Fashion is a veil,

A Bejewelled Maiden with a Parakeet (detail)
India (Deccan, Golconda), ca. 1670–1700
Opaque watercolor and gold on paper, $8^3/_4$ x 12 $^1/_2$ in.
Gift of Cynthia Hazen Polsky, 2011 2011.585

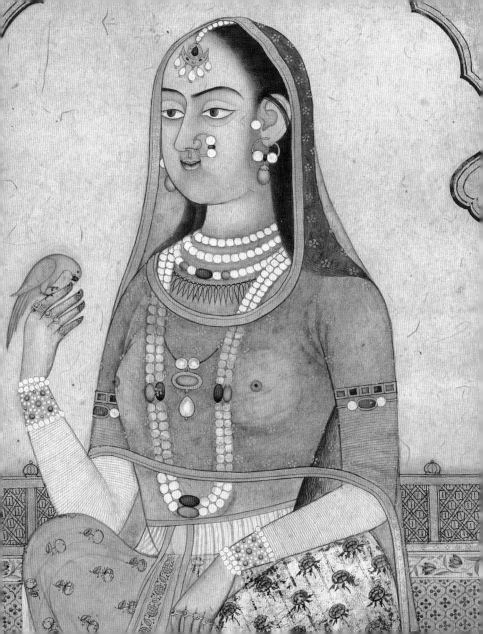

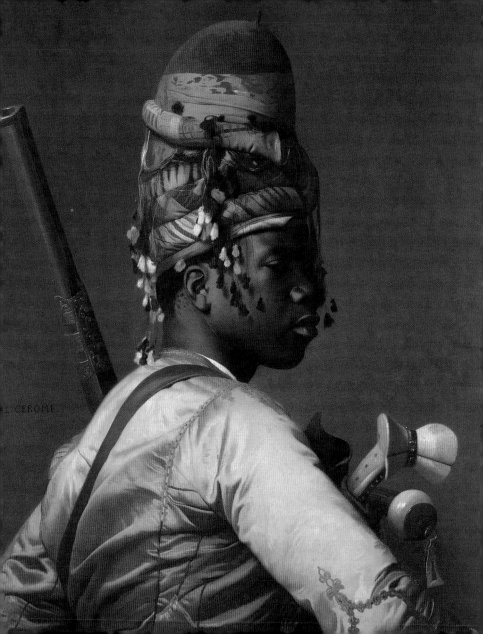

fashion is a headdress.

Fashion is for princesses,

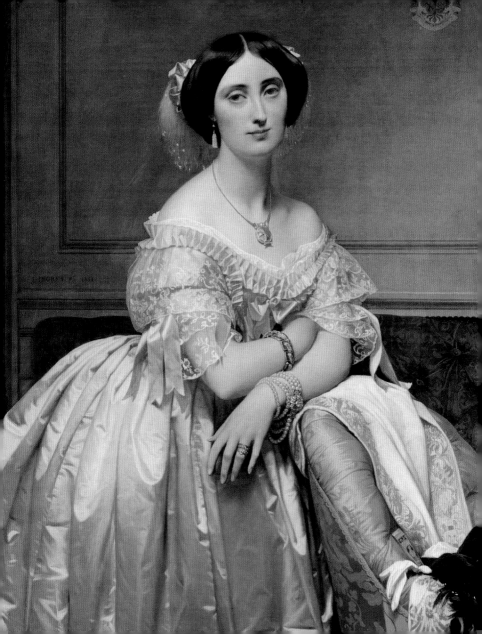

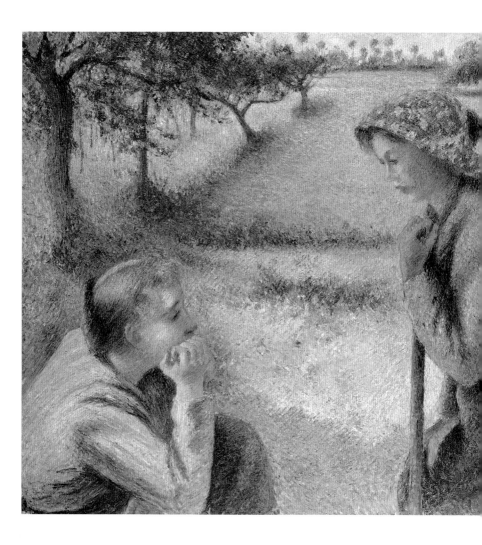

fashion is for peasants.

Fashion is a belt,

Evening Belt (detail)
American, 1940–49
Silk, leather
Brooklyn Museum Costume Collection at The Metropolitan
Museum of Art, Gift of the Brooklyn Museum, 2009;
Gift of Arturo and Paul Peralto-Ramos, 1954 2009.300.1188

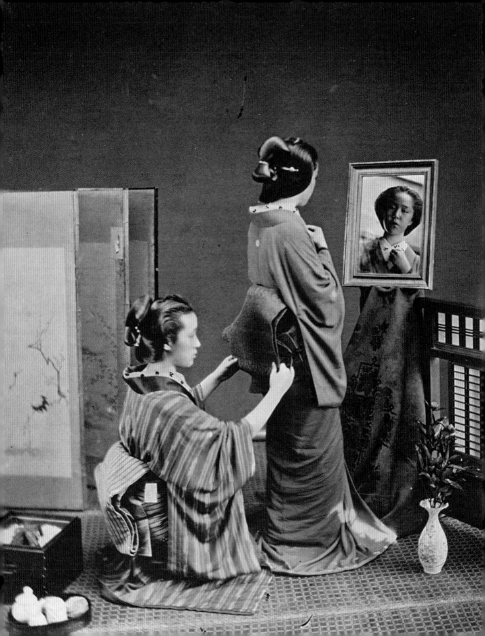

fashion is an obi.

Fashion is bejeweled,

Jeweled Bracelet
Byzantine, 6th–7th century
Gold, silver, pearl, amethyst, sapphire, glass, quartz, emerald plasma; H. 1 1/2 in.
Gift of J. Pierpont Morgan, 1917 17.190.1671

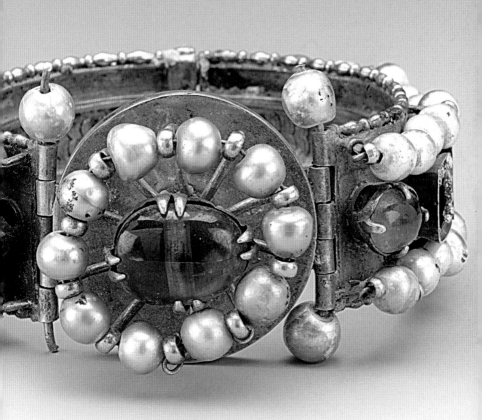

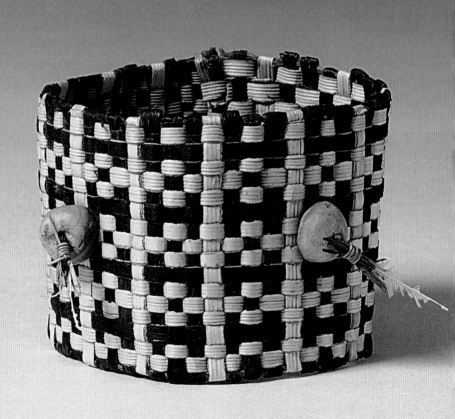

fashion is natural.

Fashion is draped sleeves,

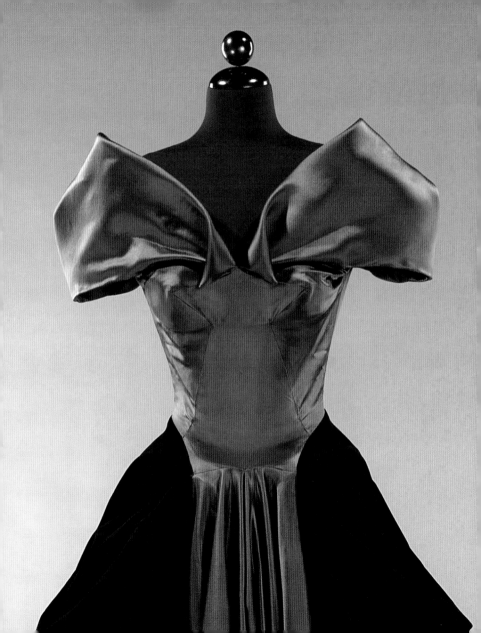

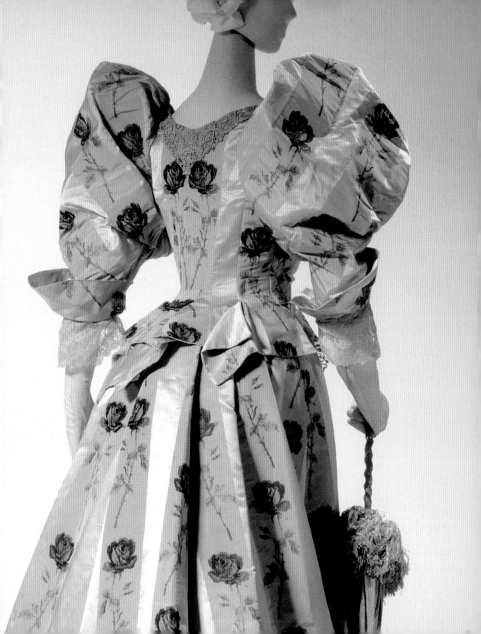

fashion is shaped sleeves.

Fashion is high heels,

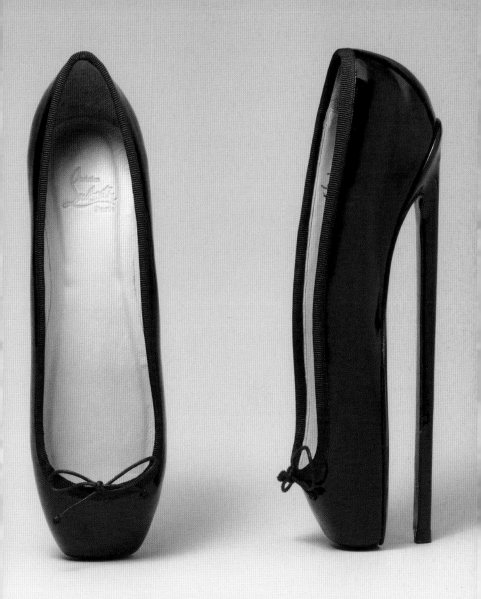

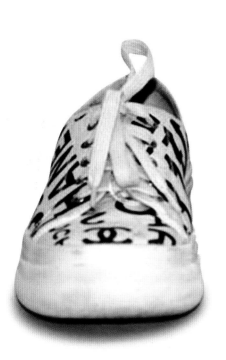

fashion is
no heels.

Fashion is costume,

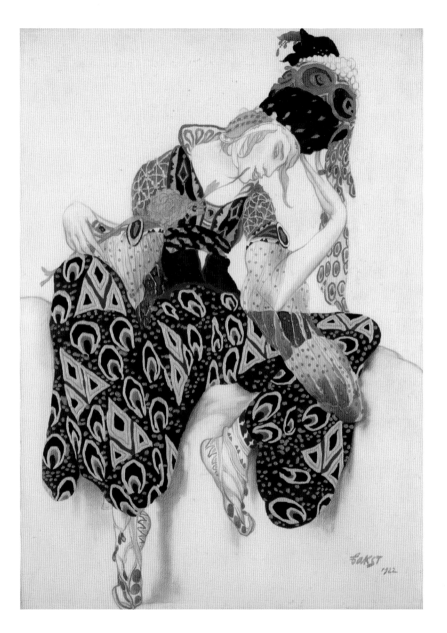

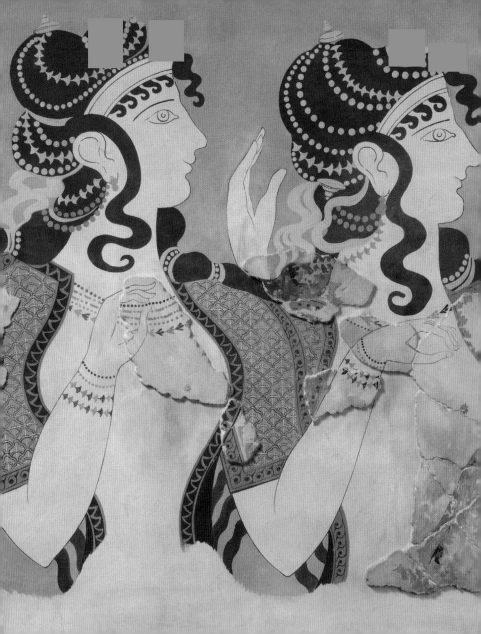

fashion is culture.

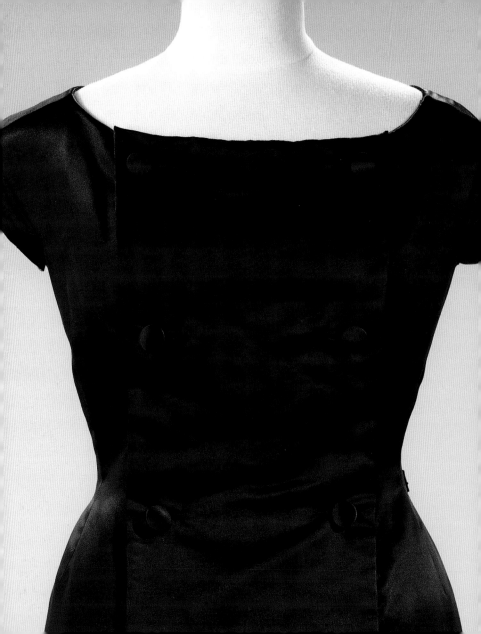

Fashion is a boatneck,

fashion is a turtleneck.

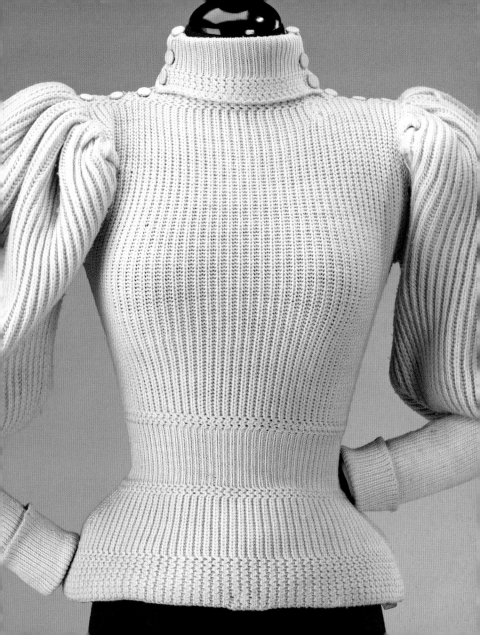

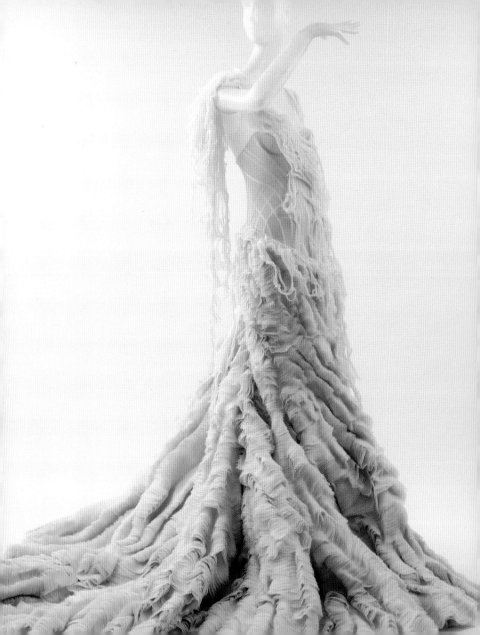

Fashion is a dress,

Oyster Dress

Alexander McQueen, British, 1969–2010

Silk, spring / summer 2003

Purchase, Gould Family Foundation Gift,

in memory of Jo Copeland, 2003 2003.462

fashion is pants.

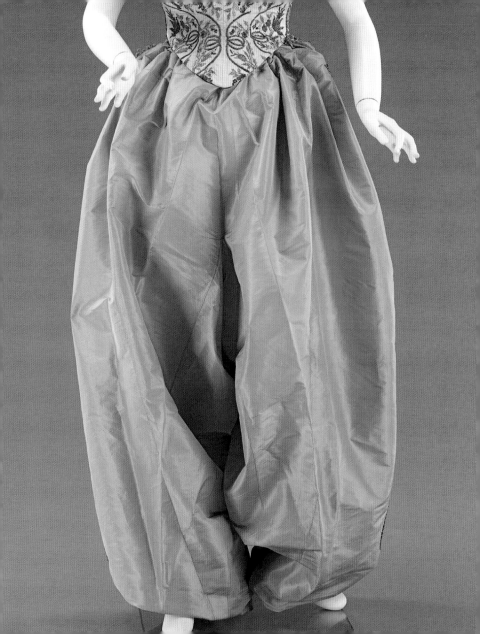

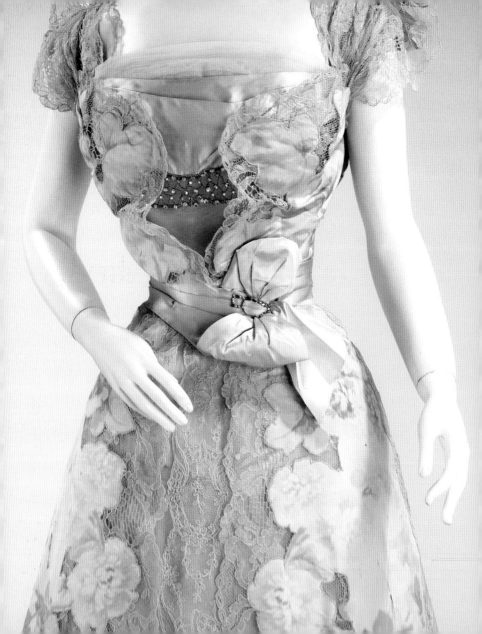

Fashion is embellished,

fashion is spare.

Evening Dress
Valentina, American (b. Russia), 1899–1989
Silk, ca. 1934
Gift of Igor Kamlukin, 1995 1995.245.1

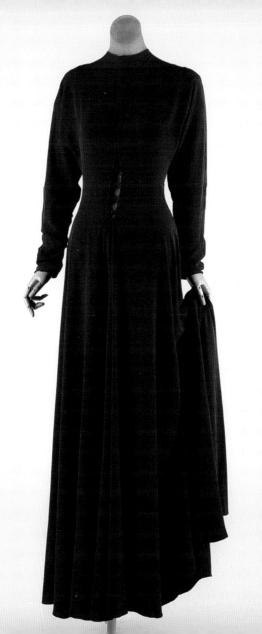

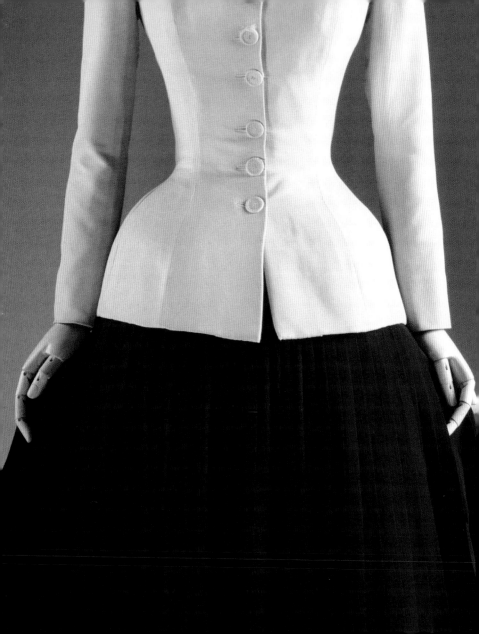

Fashion is a wasp waist.

fashion is an Empire waist.

Evening Dress
French, 1804–05
Cotton
Purchase, Gifts in memory of Elizabeth N. Lawrence, 1983 1983.6.1

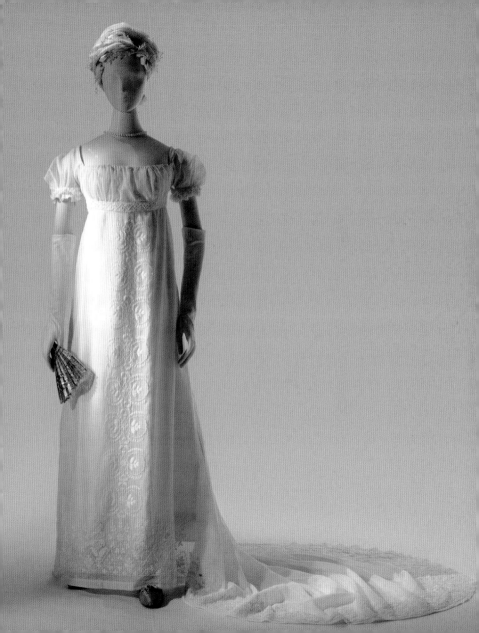

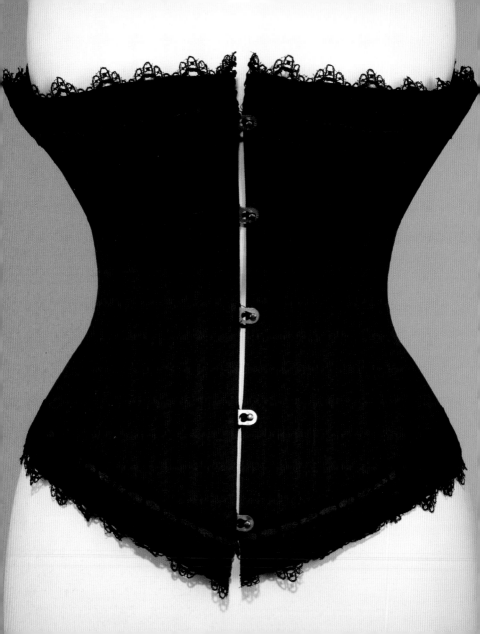

Fashion is intimate,

fashion is public.

Dress

Dolce & Gabbana, Italian, founded 1982

Synthetic, silk, cotton; ca. 2003

Gift of Dolce & Gabbana, 2005 2005.71.1

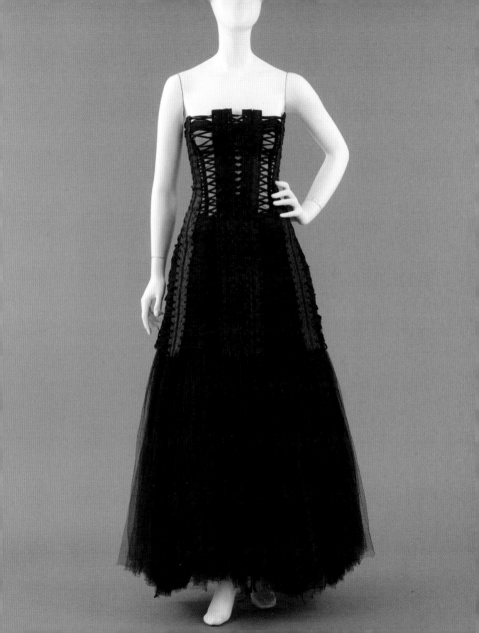

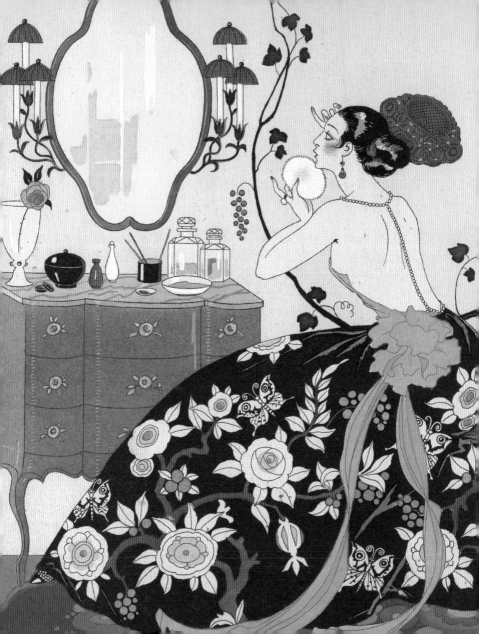

Fashion is vanity,

Le bonheur du jour; ou, Les graces a la mode (detail)

George Barbier, French, 1882–1932

Paper, 12^1/$_2$ × 17^3/$_4$ in., 1924

Purchase, The Paul D. Schurgot Foundation Inc. Gift, 2002 2002.10a–t

fashion is carefree.

Handkerchief
John Held Jr., American, 1889–1958
Silk, 1928
Gift of Mrs. Sidney Bernard, 1956 C.I.56.33.29

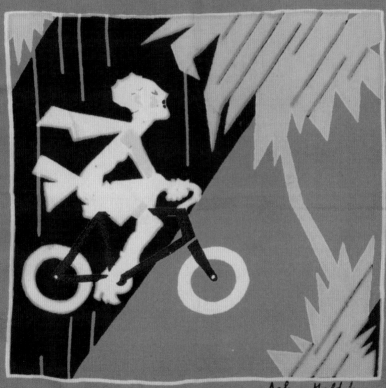

John Held jr

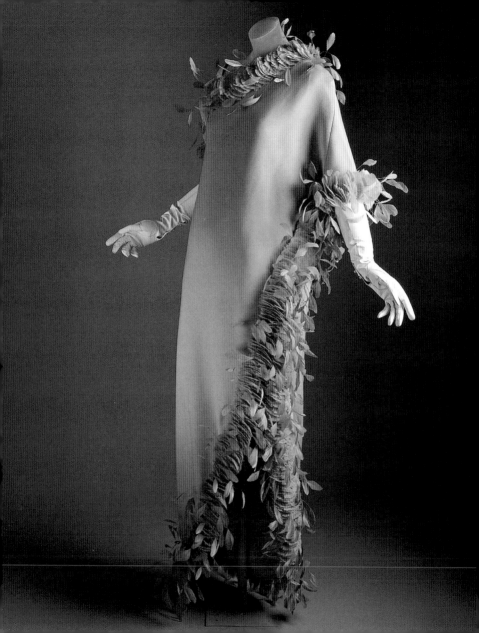

Fashion is made to order,

fashion is ready-to-wear.

Dress

Diane Von Furstenberg, American (b. Brussels), b. 1946

Cotton / rayon blend, 1975–76

Gift of Richard Martin, 1997 1997.487

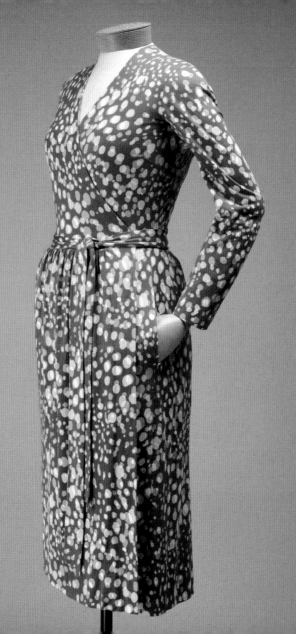

à mon cher copain
Emile Bernard
Vincent

Fashion is a fez,

fashion is a bonnet.

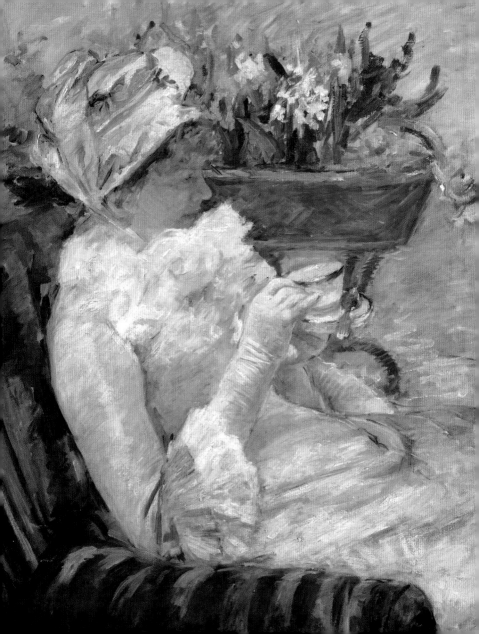

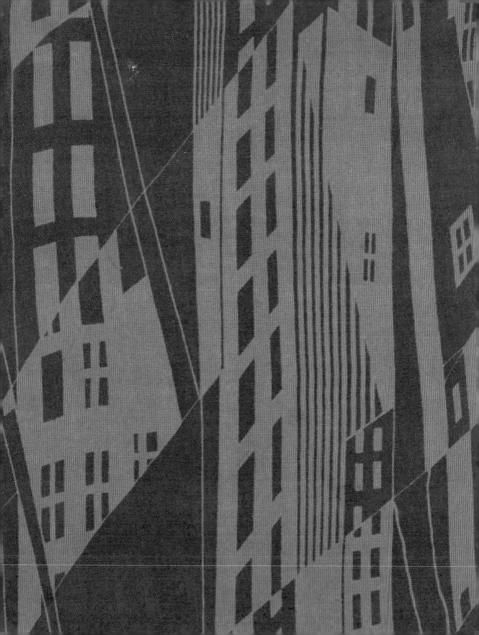

Fashion is sampled,

fashion is made.

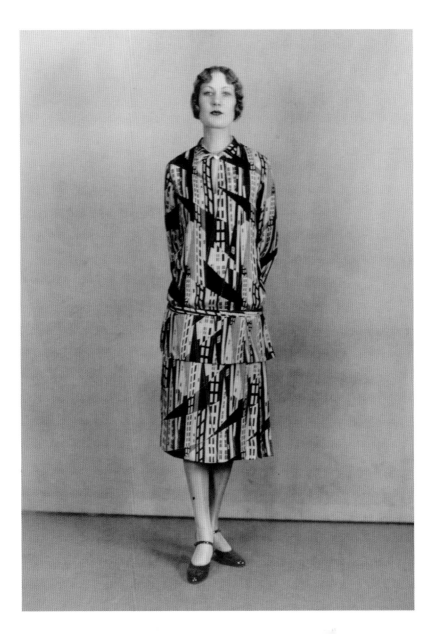

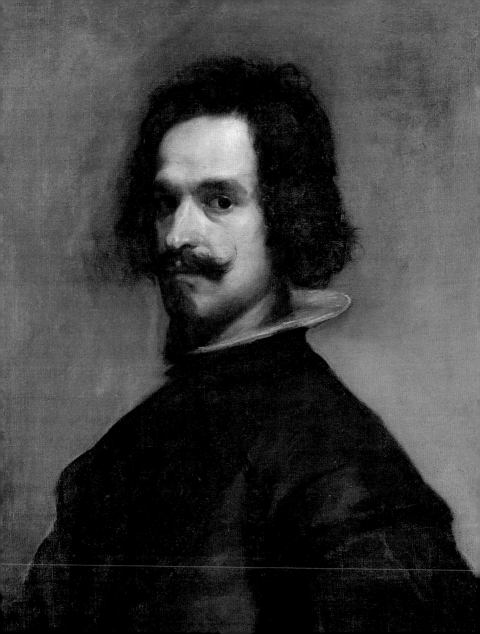

Fashion is plain,

fashion is fancy.

James Stuart (1612–1655), Duke of Richmond and Lennox
Anthony van Dyck, Flemish, 1599–1641
Oil on canvas, 85 x 50¹/₄ in., ca. 1633–35
Marquand Collection, Gift of Henry G. Marquand, 1889 89.15.16

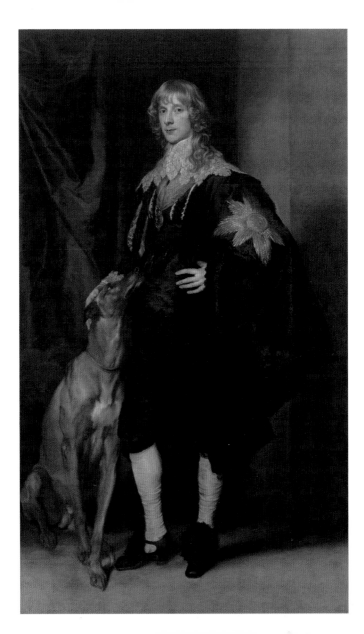

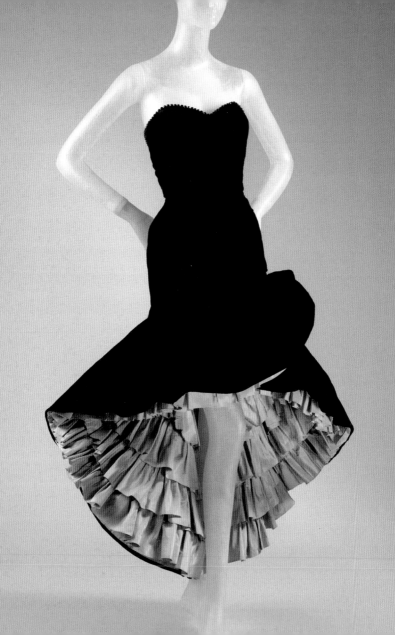

Fashion is frills,

fashion is function.

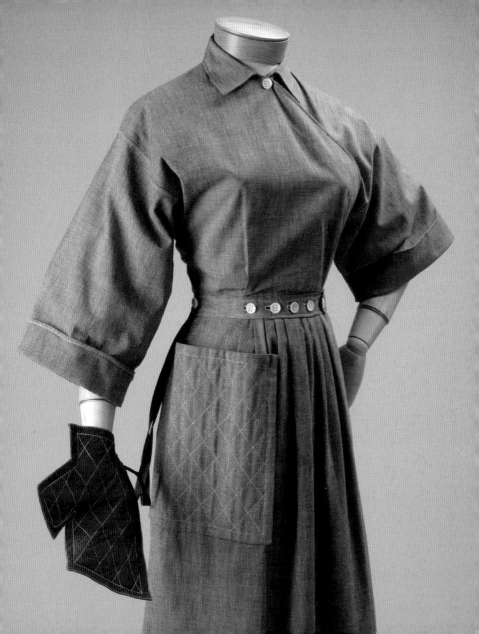

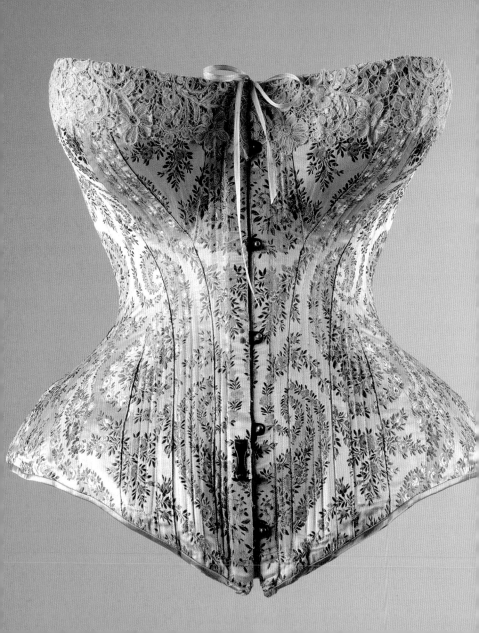

Fashion is a corset,

fashion is a brassiere.

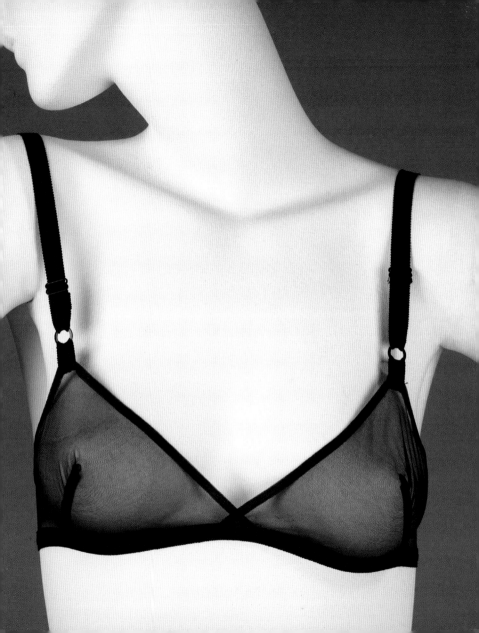

Fashion is handmade,

Interior with a Woman Writing and Sewing (detail)
Daughters of Bishop Parr, British
Watercolor, 8⁵/8 × 15 in., 19th century
Gift of Lincoln Kirstein, 1991 1991.1257.2

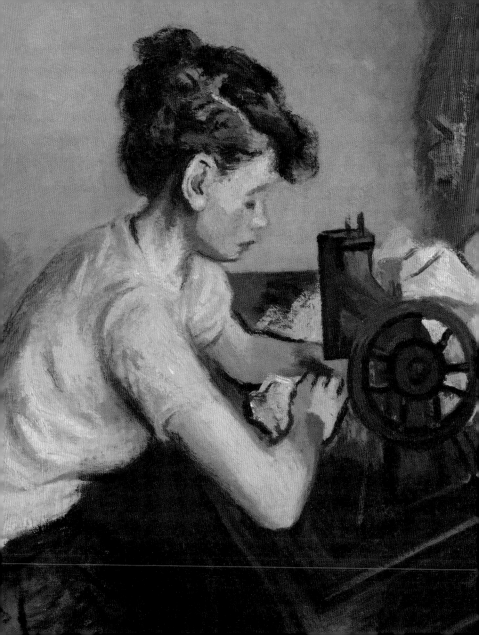

fashion is machine made.

Fashion is comedy,

Mezzetin (detail)

Antoine Watteau, French, 1684–1721

Oil on canvas, 21³/₄ × 17 in., ca. 1718–20

Munsey Fund, 1934 34.138

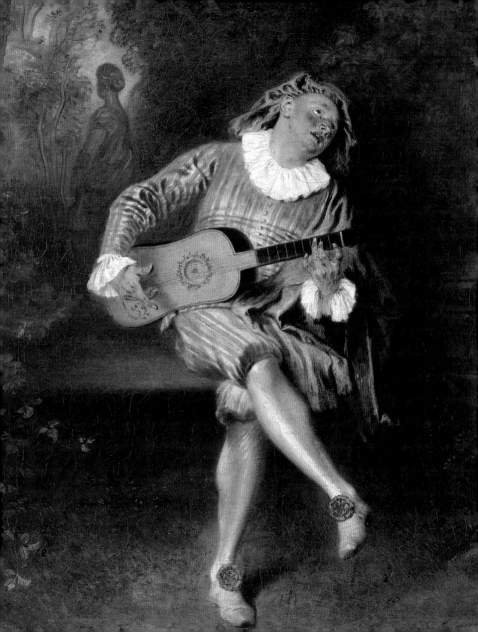

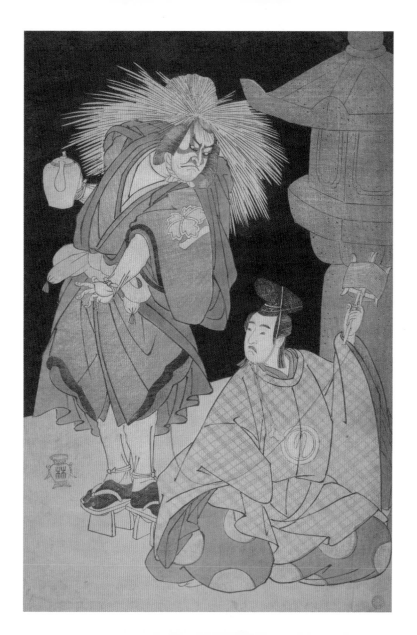

fashion is drama.

Fashion is advertisement,

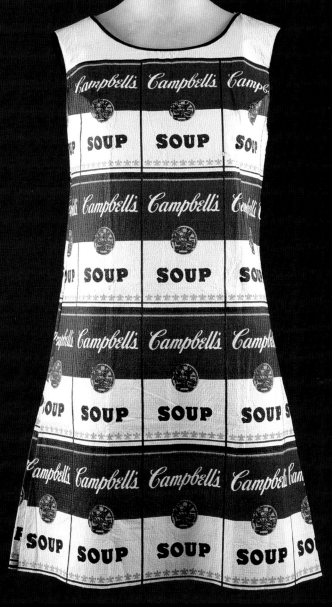

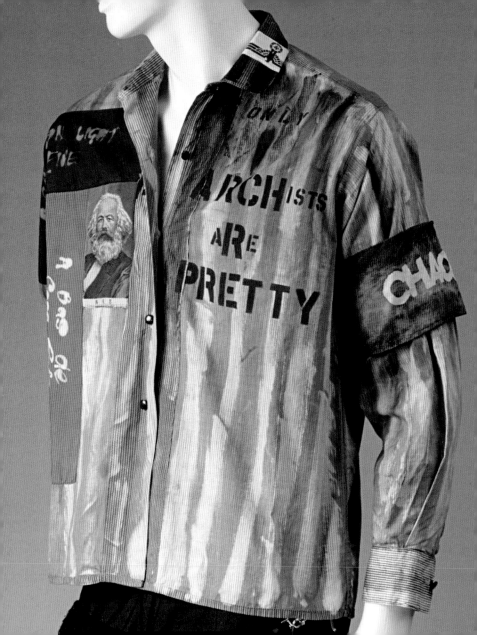

fashion is expression.

Shirt

Vivienne Westwood, British, b. 1941

Cotton, 1976

Gift of Barbara and Gregory Reynolds, 1985 1985.375.6

Fashion is
a bowtie,

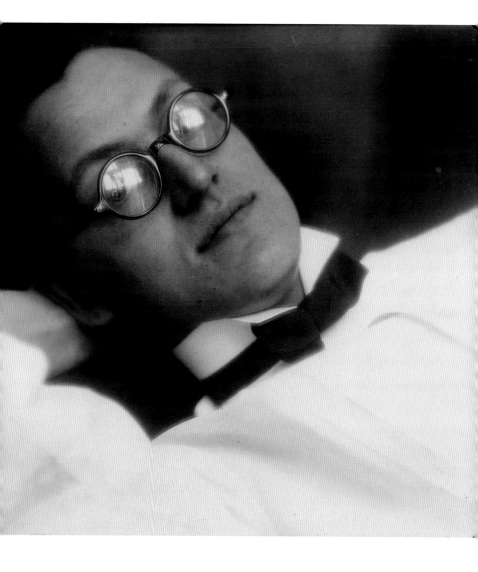

fashion is a necktie.

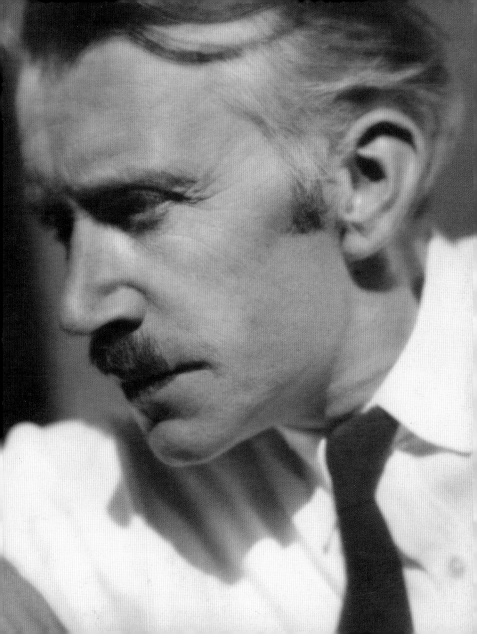

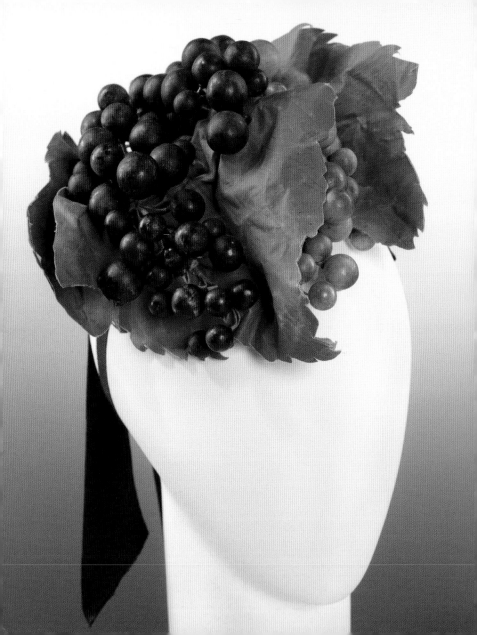

Fashion is fruits,

fashion is vegetables.

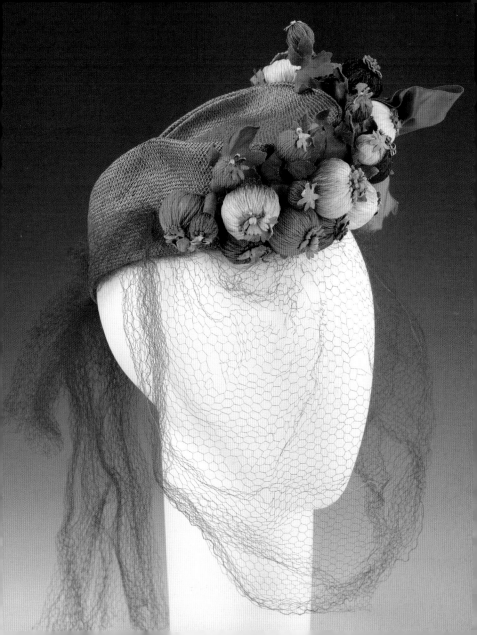

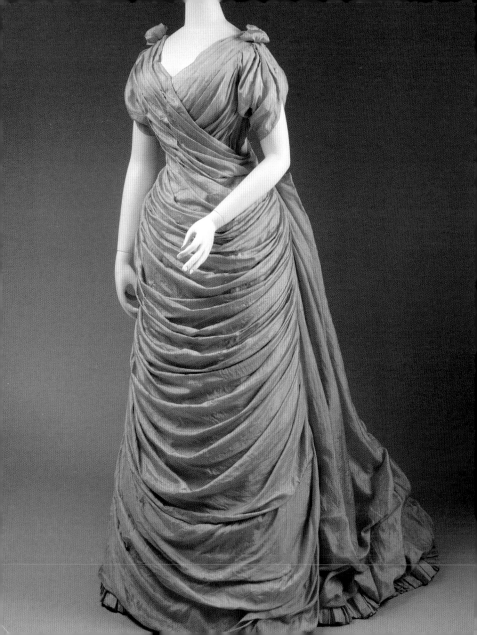

Fashion is draped,

fashion is tailored.

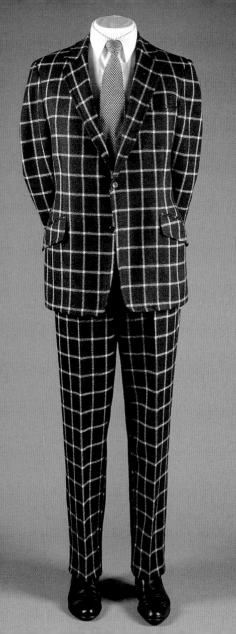

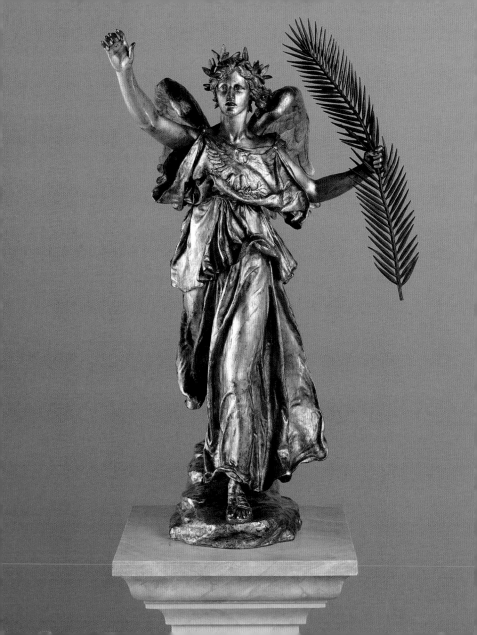

Fashion is gilded,

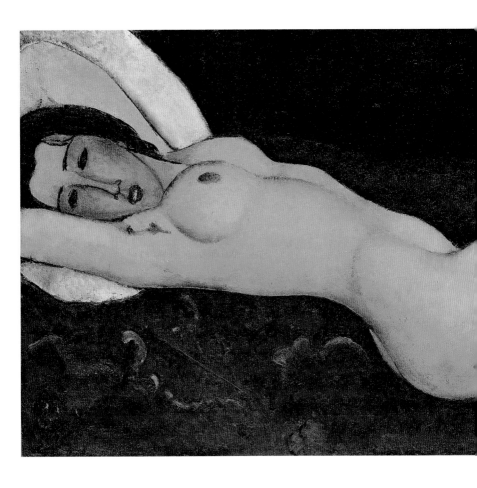

fashion is bare.

Reclining Nude
Amedeo Modigliani, Italian, 1884–1920
Oil on canvas, 23⁷/8 × 36¹/2 in., 1917
The Mr. and Mrs. Klaus G. Perls Collection, 1997 1997.149.9

Fashion is a cocktail dress,

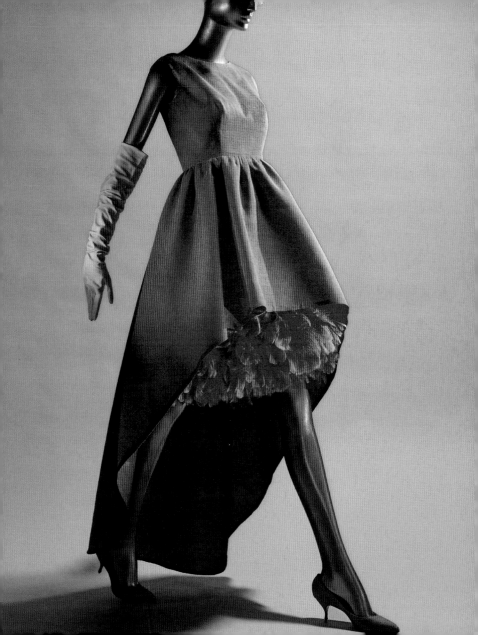

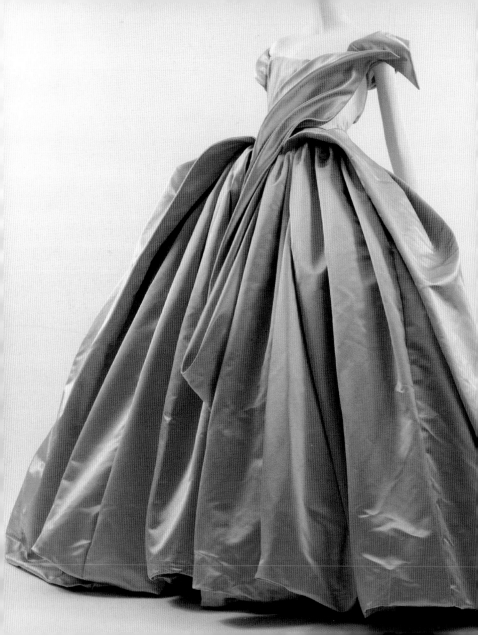

fashion is a ball gown.

"Propaganda" Dress
Vivienne Westwood, British, b. 1941
Silk, fall / winter 2005–06
Purchase, Friends of The Costume Institute Gifts, 2006 2006.197a–f

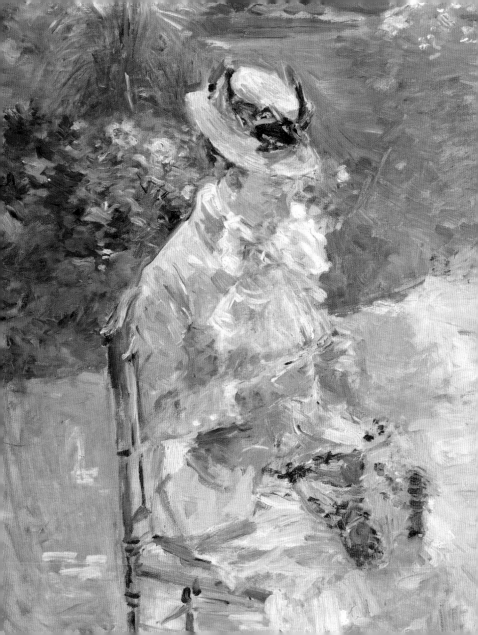

Fashion is knitted,

fashion is woven.

A Woman Weaving, Seated at a Hand Loom
Kitagawa Utamaro, Japanese, 1754–1806
Polychrome woodblock print; ink and color on paper, $14^3/_4 \times 9^7/_8$ in., ca. 1796
Rogers Fund, 1914 JP152

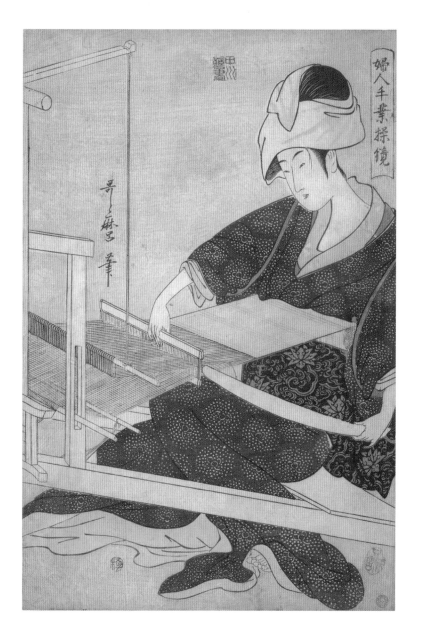

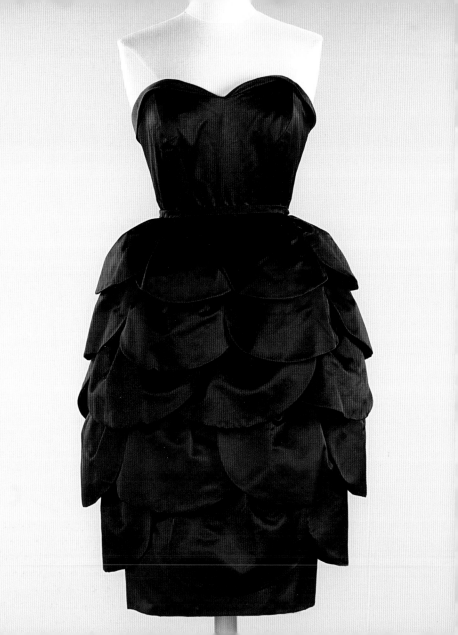

Fashion is satin,

Cocktail Ensemble
Mainbocher, American, 1890–1976
Silk, ca. 1955
Brooklyn Museum Costume Collection at
The Metropolitan Museum of Art, Gift of the Brooklyn Museum, 2009;
Gift of Mrs. Ian B. MacDonald, 1965 2009.300.383a, b

fashion is velvet.

Evening Dress
House of Worth, French, 1858–1956
Silk, 1898–1900
Gift of Miss Eva Drexel Dahlgren, 1976 1976.258.1a, b

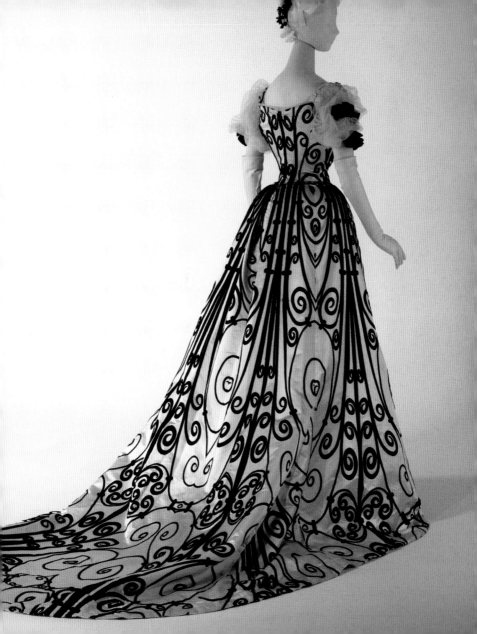

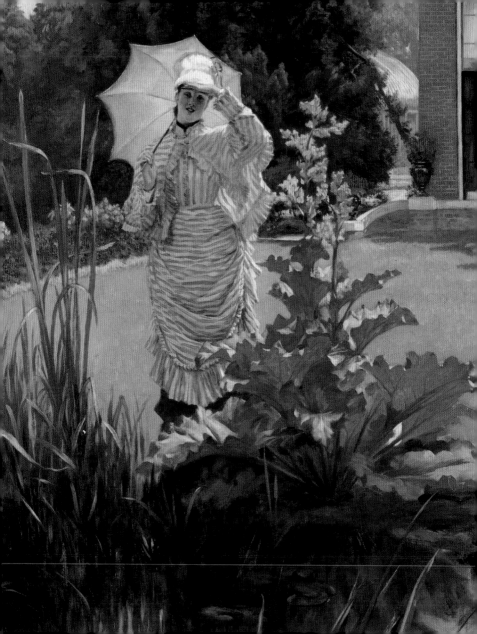

Fashion is a parasol,

fashion is a purse.

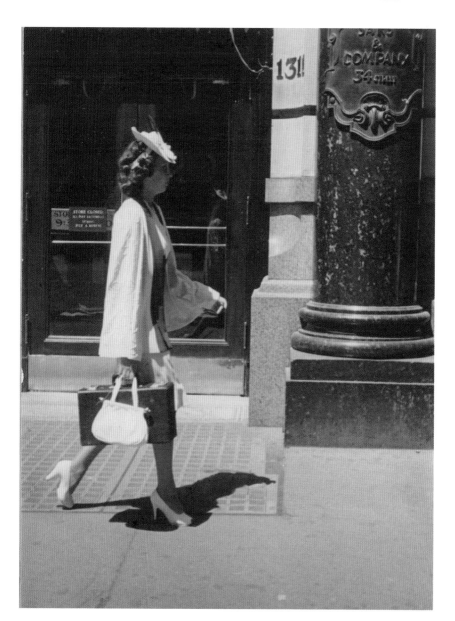

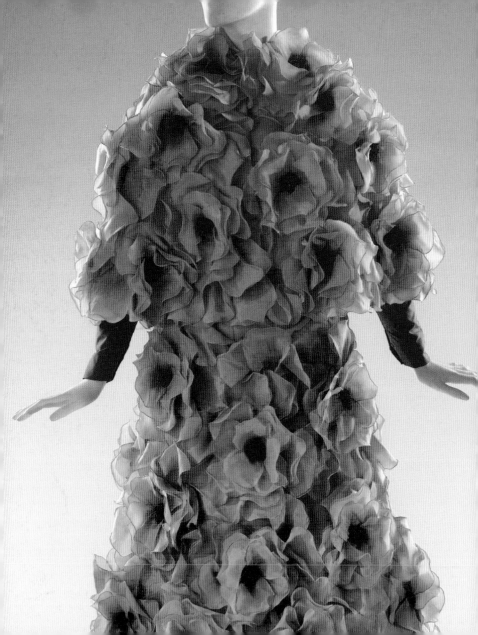

Fashion is flora,

fashion is fauna.

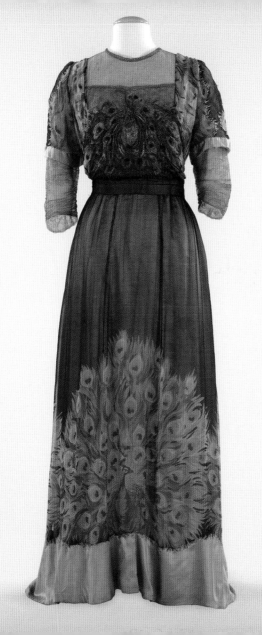

Fashion is denim,

Shoulder Bag

Bloomingdale's, American, founded 1872

Cotton, leather, metal; ca. 1968

Gift of Serendipity 3 Denim Clothing Collection, 1977 1977.333.53

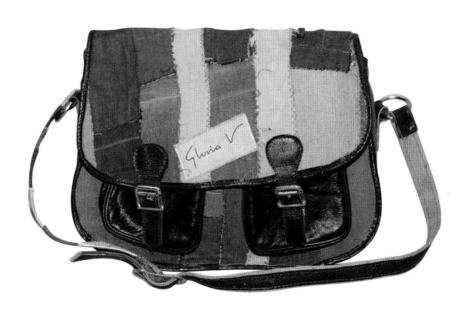

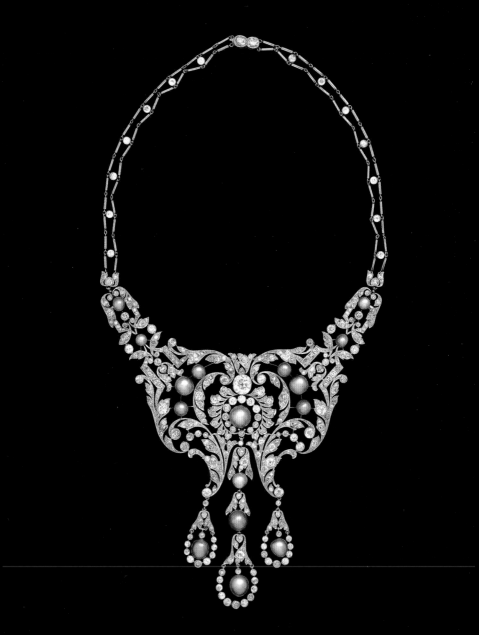

fashion is diamonds.

Fashion is worn,

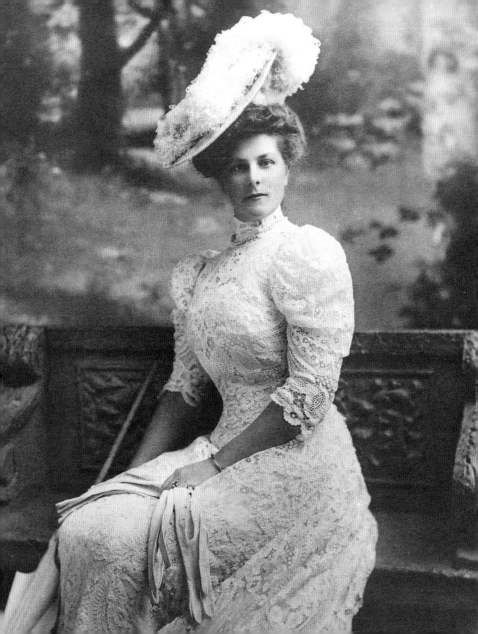

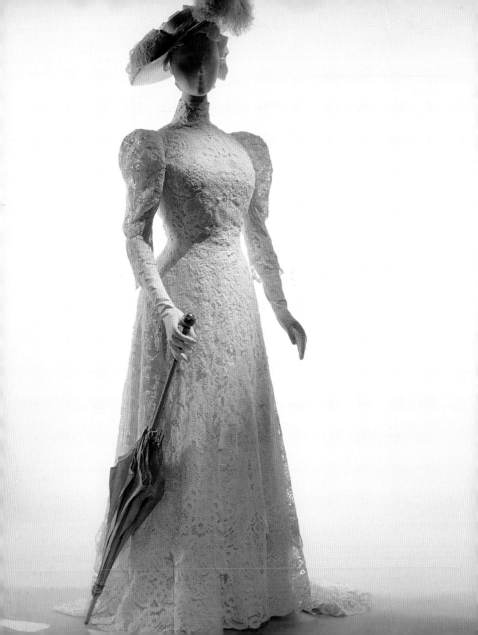

fashion is treasured.

Afternoon Dress
American, 1901
Cotton
Gift of Winifred Walker Lovejoy,
in memory of Winifred Sprague Walker Prosser, 1980 1980.590.1

All of the works of art in this book are from the collection of The Metropolitan Museum of Art. Every reasonable effort has been made to identify and contact copyright holders but in some cases, they could not be traced. If you hold or administer rights for works of art published here, please contact us. Any errors or omissions will be corrected in subsequent printings.

Produced by the Department of Printed Product, The Metropolitan Museum of Art: text by Mimi Tribble; photography by The Metropolitan Museum of Art Photograph Studio.

Cover designed by John Gall. Interior designed by Anna Raff.

Library of Congress Control Number: 2013945526

ISBN: 978-1-4197-1168-8

Printed and bound in Hong Kong

10 9 8 7 6 5 4 3 2 1

The Metropolitan Museum of Art
1000 Fifth Avenue
New York, NY 10028
www.metmuseum.org

THE ART OF BOOKS SINCE 1949

115 West 18th Street
New York, NY 10011
www.abramsbooks.com